IMAGES
of England

CHELSEA

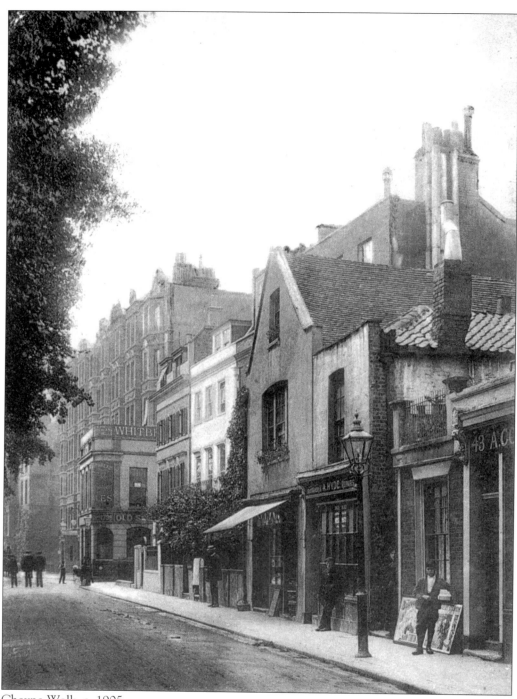

Cheyne Walk, *c*. 1905.

IMAGES
of England

CHELSEA

Compiled by
Patrick Loobey

TEMPUS

First published 1999
Copyright © Patrick Loobey, 1999

Tempus Publishing Limited
The Mill, Brimscombe Port,
Stroud, Gloucestershire, GL5 2QG

ISBN 0 7524 0687 6

Typesetting and origination by
Tempus Publishing Limited
Printed in Great Britain by
Midway Clark Printing, Wiltshire

Born in 1947, Patrick Loobey has lived within the Borough of Wandsworth all his life, except for one ten-year absence. He joined the Wandsworth Historical Society in 1969 and has served on its archaeological, publishing and management committees, being Chairman in 1991-1994 and presently. Having collected Edwardian postcards of London for over twenty-five years, he has a wide-ranging collection encompassing many street scenes and subjects. Since 1994, Patrick has compiled picture books covering Putney, Wandsworth, Battersea, Clapham, Wimbledon, Barnes, Mortlake, East Sheen, Merton, Morden and Mitcham, Chiswick and Brentford. Many more titles are planned to follow this on Chelsea.

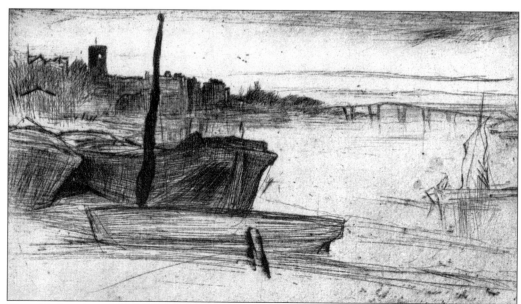

The old church and Battersea Bridge, Chelsea, by James McNeill Whistler, *c.* 1880.

Contents

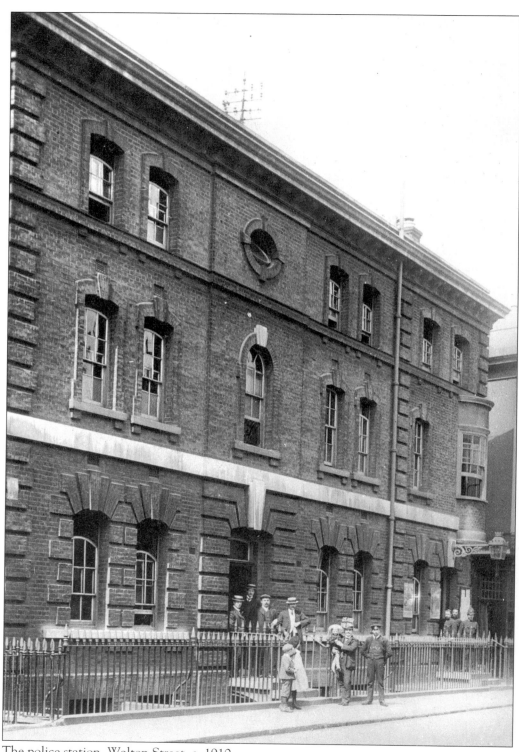

The police station, Walton Street, *c.* 1910.

Introduction

This book celebrates the riverside town of Chelsea. The area probably has more blue plaques to the acre than anywhere else: to the many artists, authors, actors, landed gentry, royalty, saints, eccentrics and architects that have resided or worked here. The street names recall the history not just of Chelsea but also of nationally and internationally famous individuals who have shaped our lives, such as Viscount Cheyne, Sir Hans Sloane, Lord Cadogan of Oakley or King Charles II whose private road is still called the King's Road. The one saint is Sir Thomas More who had a veritable palace near the Thames before meeting his fate on Tower Hill on 6 July 1535. Mention is also made of a murderer and of a spy, but of only one inventor, William Friese Green, who patented the movie camera. Chelsea was at one time famous for its nurseries; in the 1830s, a single tulip from a King's Road gardener was catalogued at 200 guineas and the first red geranium seen in England was raised in Chelsea by a Mr Davis about 1822. The architecture is of a varied and sometimes novel nature that has now gained protection. Over half of the streets have been designated a Conservation Area and in 1974 a proposal was made by the Save our London Action Group for all of Chelsea to become a conservation area. The area was never an industrial centre, as any workshops were sited behind Mews or placed near the Thames at Lots Road. This book attempts to record some of the many changes that have taken place this century, through the medium of photographs. Chelsea has been and always will be an area of change: developers are always waiting in the wings, with their ball and chain, to alter the skyline.

The author has been fortunate in acquiring a large collection of glass plate negatives, originally photographed by Mr R.J. Johns in the period 1911 to 1936. Many of these views have not been published before and have been supplemented with views from the author's collection of approximately 20,000 views of London and its suburbs. Reproductions of all the views in this book are available from Patrick Loobey, 231 Mitcham Lane, Streatham, SW16 6PY (Tel. 0181-769 0072).

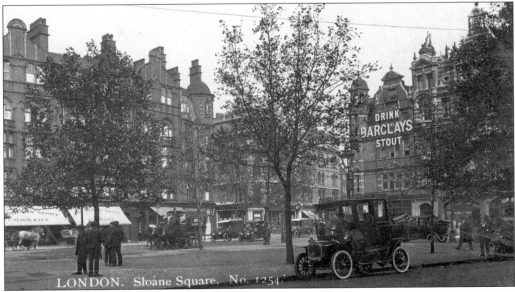

Sloane Square, c. 1922.

Bibliography

Landlords to London, Simon Jenkins, 1975
Lure and Love of London's River, A.G. Linney, 1932
Old and New London, E. Walford, 1882
Where they lived in London, Maurice Rickards, 1972
London Statues and Monuments, Margaret Baker, 1995
Chelsea Borough Guides
Royal Borough of Kensington and Chelsea Guides
Metropolitan District Railway, Charles E. Lee, 1956
Chelsea Old Church 1941-1950, Leslie Mathew & Moberly Bell, 1958
Chelsea, Thea Holme, 1972
Memorials of Old Chelsea, Alfred Beaver, 1892, republished 1972
The Cadogan Estate, Robert Pearman, 1986
Chelsea, Thomas Faulkner, 1829
The South Kensington Estate of Henry Smith's Charity, Dorothy Stroud, 1975
Chelsea Past, Barbara Denny, 1996
Chelsea, G.E. Mitton & W. Bessant, 1903
Chelsea, In the Olden & Present Times, G Bryan, 1869
Chelsea, From the Five Fields to the World's End, R. Edmonds, 1956
Modern Buildings in London, I. Nairn, 1964
C.R. Mackintosh, The Chelsea Years, A. Crawford, 1994
Kensington & Chelsea, A. Walker & P. Jackson, 1987
A History of the Guinness Trust, P. Malpass, 1998
The Black Plaque Guide to London, F. Barker and D. Silvester-Carr, 1987
A Place called Chelsea, John Gullick, c. 1973
Survey of London, Vol. XLI, GLC, 1983
The English School, its Architecture and Organisation, Vol. II: 1870 to 1970, M. Seaborne & Roy Lowe, 1977
The Amber Valley Gazetteer of Greater London's Suburban Cinemas, 1946-1986, Malcolm Webb, 1986
Whitelands College – The History, Malcolm Cole, 1982
Whitelands College – May Queen Festival, Malcolm Cole, 1981
The Local Studies library at Chelsea Old Town Hall has a wealth of information on old Chelsea and the staff are most helpful to those enquiring on local history.

One
Chelsea Riverside

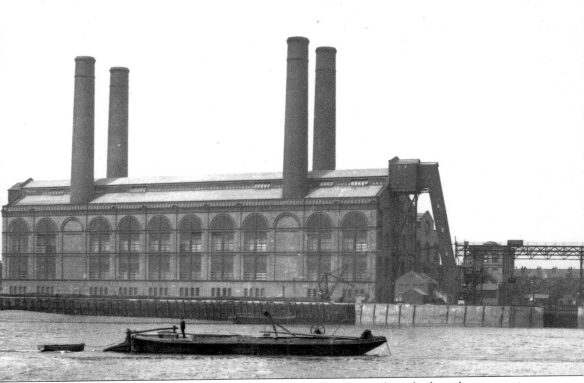

Lots Road power station, c. 1915. The Metropolitan District Railway had used steam trains from its inauguration in 1868. In 1901 when the American Charles Tyson Yerkes took control of the company, the decision was taken to form the Metropolitan District Electric Traction Co. Ltd to supply electricity to the system or 'electrolisation' as they called it. Work on the powerhouse at Chelsea commenced in March 1902 and electricity was produced by February 1905. The original capacity was to supply 44,000 kW. Coal was brought by barge up the Thames on almost every tide; the power station consumed 800 tons per day and a reserve of 13,000 tons was maintained on site. The station was coal-powered until 1963 when it was converted to oil and two of the 275ft tall chimneys were removed. The London Underground system will soon take all of its power from the National Grid and Lots Road power station will stop generating electricity by 5 July 2000. It will be decommissioned by 5 January 2001 by which time any hazardous substances will have been removed; the site will then be handed over to developers.

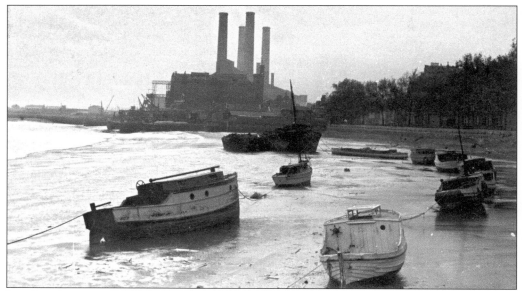

Lots Road power station, *c.* 1925. During the medieval period and up to 1826 the Lots were four acres of common grazing ground let out from 12 August to February for cattle to graze in the water meadows. These lots were known as Lammas lands after the Lammas festival of the first fruits of the harvest. The muddy foreshore of Chelsea Reach is now covered by the houseboats of the Chelsea Yacht and Boat Co. Housing on the river here commenced after the Second World War, with moored motor torpedo boats alleviating the post-war housing shortages. The houseboats today are mainly converted steel barges.

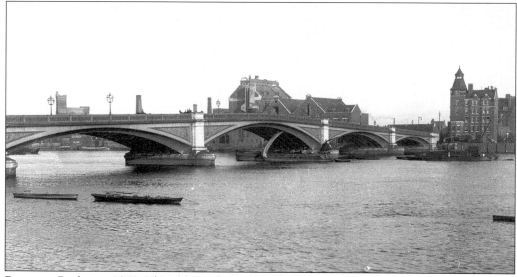

Battersea Bridge, *c.* 1910. The old wooden bridge, drawn and painted by many artists including Turner and Whistler, was opened in 1772 replacing the ancient ferry to 'Chelchehith'. The ferry, owned by the Crown, was sold by James I to the Earl of Lincoln for £40 in 1603. The bridge was closed in November 1885 and the Earl of Rosebery, first chairman of the London County Council, opened the present bridge on 21 July 1890. It was designed by Sir Joseph and Mr Edward Bazalgette and cost £143,000.

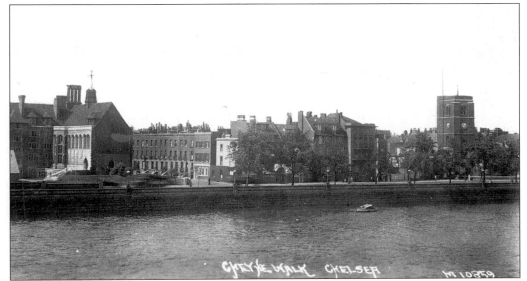

Cheyne Walk from Battersea Bridge, *c.* 1930. The tower of Chelsea old church is on the right and on the left is the imposing bulk of Crosby Hall. To the left of the church, demolition is under way of the Lombard Café and the toyshop on the corner of Old Church Street. (See also pp. 13 and 58)

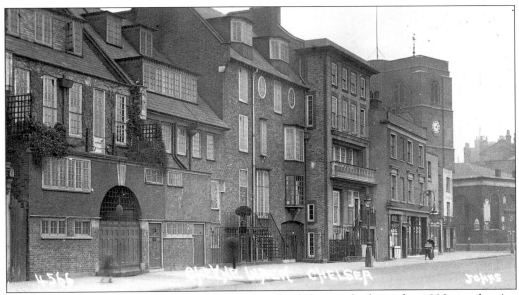

Cheyne Walk, *c.* 1912. The four properties on the left were built in the 1890s in the Art Nouveau style. Number 74 on the left, with its beaten copper front door, is where the artist James McNeill Whistler lived (see also p. 20). The sculptor Jacob Epstein had his studio at no. 72 from 1909 to 1914. This row was destroyed in an air raid in 1941; the site, once that of Sir Thomas More's orchard, was later used for a sunken garden. The three-storey building, where the lady with a pram is passing, was the Rising Sun public house.

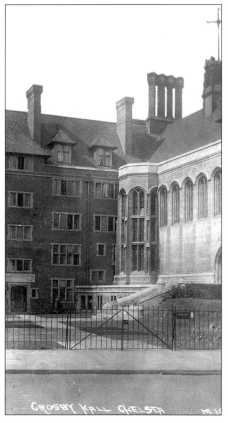

Crosby Hall, Cheyne Walk, *c.* 1930. The banqueting hall, originally situated on the east side of Bishopsgate in the City, was built in 1466 for Sir John Crosby, a rich wool merchant, warden of the Grocers' Company and a soldier. Sir Thomas More bought a lease on the hall in 1523 for £150 but it is doubtful whether he actually lived there. The hall is mentioned three times in Shakespeare's *Richard III.* The building was later used as a warehouse and a restaurant. Bought in 1907 by the Chartered Bank of India, Australia & China, they set in motion plans to demolish the hall. Sufficient funds were not found to leave it on the original site and it was dismantled and re erected on the former garden of Sir Thomas More's house at Chelsea. The building was put into use by the British Federation of University Women, which added in 1927 a hall of residence designed by Walter H. Godfrey. The hall was bought in 1988 from the Greater London Council by Christopher Moran who has proceeded to add new structures to the old hall in the style of the sixteenth century. The architect for the new scheme was Russell Taylor who was advised by Simon Thurley, director of the Museum of London, on the historic building styles in vogue between the fifteenth and seventeenth centuries. The river frontage is in the style of the 1520s, the date of Sir Thomas More's demolished mansion. With much detailing of the stonework and brick coursing, a palace has been replaced on the Chelsea riverside.

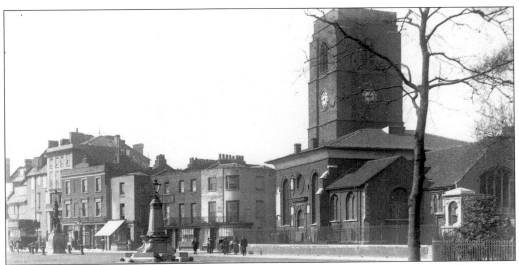

Chelsea old church, *c.* 1914. The parish church of Chelsea, dating from the fifteenth century, was virtually destroyed on the night of 16/17 April 1941 when several landmines were dropped here. The chapel commissioned by Sir Thomas More in 1528 survived and became the spur to rebuild the church. Immediate retrieval of 80 per cent of the shattered monuments in 1941 enabled them to be replaced in the church together with a plaque to the five firewatchers killed on that dreadful night. Architect of the restoration was Walter H. Godfrey CBE, FSA, FRIBA, who had overseen the resiting and rebuilding of Crosby Hall. The reconstruction was completed in stages; the chancel and Lawrence chapel, begun in 1953, were complete when the church was rehallowed on 4 May 1954. The nave, west gallery and tower were begun in 1955 and completed by 1958 when they were reconsecrated on 13 May by the Lord Bishop of London in the presence of HM Queen Elizabeth the Queen Mother. The sundial on the tower bears the date 1692 but an inscription also adds that it was remade in 1957. A statue of Sir or Saint Thomas More by L. Cubitt Bevis was unveiled in front of the church on 21 July 1969 by Dr Henry King, speaker of the House of Commons.

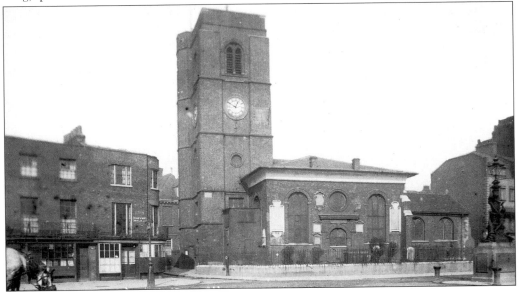

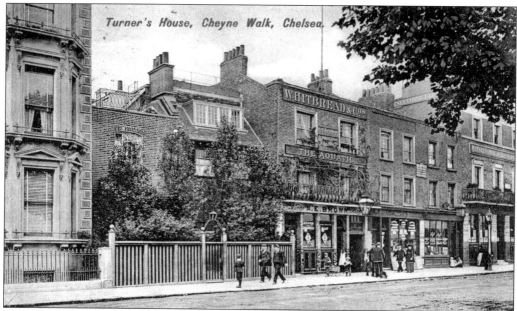

Turner's House, Cheyne Walk, Chelsea.

Turner's house, now 119 Cheyne Walk, seen about 1905 (above) and 1930 (below). To the right of Turner's house is the Aquatic public house (today a private house) and three doors further along is the King's Arms pub, also closed and used today as offices. The later photograph shows the improvements carried out during restoration of Turner's house, including removal of the large bushes obscuring views of the building. The painter Joseph Mallord Turner lived his last years here and had the iron railing installed on the roof for him to admire sunsets across the River Thames. He died here in 1851.

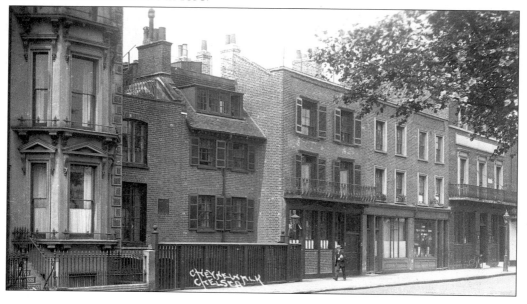

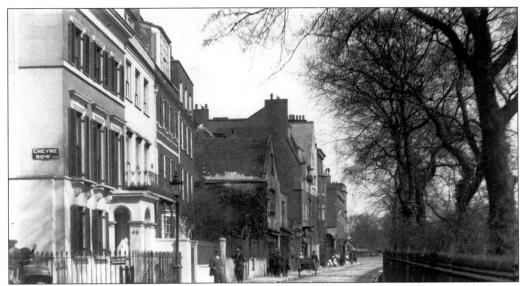

Cheyne Walk, with Cheyne Row on the left, c. 1925. The Feathers Inn once stood on this corner, now occupied by no. 49 Cheyne Walk. The first four houses remain today but the rest of this parade has been demolished and rebuilt. Further along was the Magpie and Stump public house which burnt down in 1886 and was replaced in 1894 by three tall Art Nouveau houses designed by C.R. Ashbee. Numbers 39 and 41 remain.

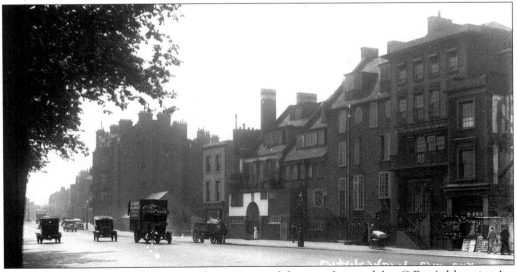

Cheyne Walk, c. 1933. On the right are several houses designed by C.R. Ashbee in Art Nouveau style. The landmines that fell on the night of 16/17 April 1941, demolishing the old parish church, also brought down nos 71-75 Cheyne Walk. The Ashbee houses were not rebuilt, but a sunken garden, called Roper Garden, was created and opened to the public in 1965. A carving there commemorates the years 1909-1914 when the sculptor Jacob Epstein lived and worked in studios on the site. William Roper had married Margaret, the eldest daughter of Sir Thomas More; William was to write the first biography of his father-in-law. On the right demolition is taking place of Lombard Terrace, a row of eighteenth-century shops next to Old Church Street.

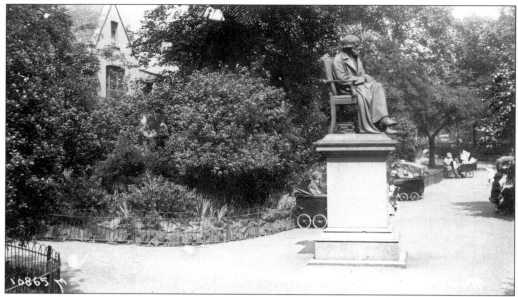

The statue of Thomas Carlyle on the Embankment Gardens of Cheyne Walk, c. 1930. The bronze statue by Sir Edgar Boehm was unveiled on 26 October 1882 to commemorate the great essayist and historian, depicted sitting on his study chair with a pile of reference books. (See also p. 25)

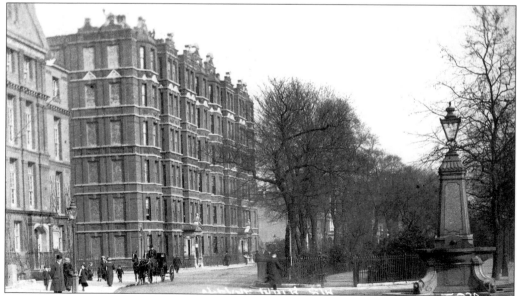

Cheyne Walk, c. 1914. An eighteenth-century inn called The Cricketers and the neighbouring Thames Coffee House were demolished in the 1880s to make way for the Carlyle Mansions, built in 1896. The block has panels of birds and flowers on the façade facing the river and also on the Lawrence Street frontage, on the left. At no. 12 Carlyle Mansions lived Reginald Blunt who founded The Chelsea Society in 1927 and also published several books on Chelsea's history. Just beyond the block, on the corner of Cheyne Row is the King's Head and Eight Bells public house.

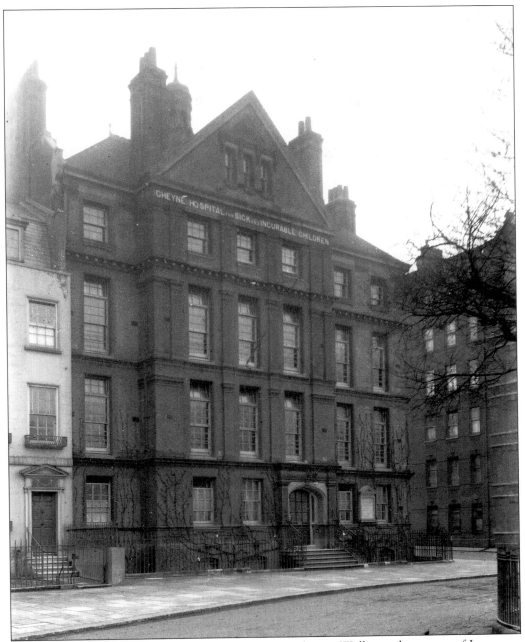

Cheyne Hospital for sick and incurable children in Cheyne Walk, on the corner of Lawrence Street, c. 1914. The Pre-Raphaelite painter William Holman Hunt moved in 1849 into one of five houses to the east of the parish church known as Prospect Place. He lived at no. 5, which in the seventeenth century was a coffee house, where local worthies would meet. Three of these houses were demolished for construction of the hospital, which was founded in 1875 to cater for children with neurological disorders and cerebral palsy. The hospital has been moved out and the building has been renamed Courtyard House and is presently being converted into luxury flats. The white fronted building to the left of the hospital is no. 62 Cheyne Walk.

Lindsey House, Cheyne Walk, *c*. 1920. Sir Theodore Mayerne, who was court physician to Henri IV and Louis XIII of France, built the original house in 1630. The property was bought approximately twenty years later by Montague Bertie, 2nd Earl of Lindsey, whose son probably carried out the rebuilding and enlarging of 1674. On the gateway there is an inscription: 'Rebuilt 1674'. The building was sold to Count Zinzendorf in 1750 for a Moravian Protestant society but he died in 1760 and the house was sold again. The house was divided into four separate properties, which remain. Marc Brunel, designer of the first Thames tunnel and father of the engineering genius Isambard Kingdom Brunel, lived here as did the artist Whistler and the locksmith Timothy Bramah.

18

Leigh Hunt's house, 22 Cheyne Walk, *c.* 1920. Leigh Hunt, playwright, essayist and poet, lived in this early eighteenth-century house from 1833 to 1840 when he moved to Kensington. At this time it was known as no. 4. The family was always close to residing in the poorhouse and the household of seven children were sometimes without bread. Leigh Hunt spent a short spell in prison for libelling the Prince Regent.

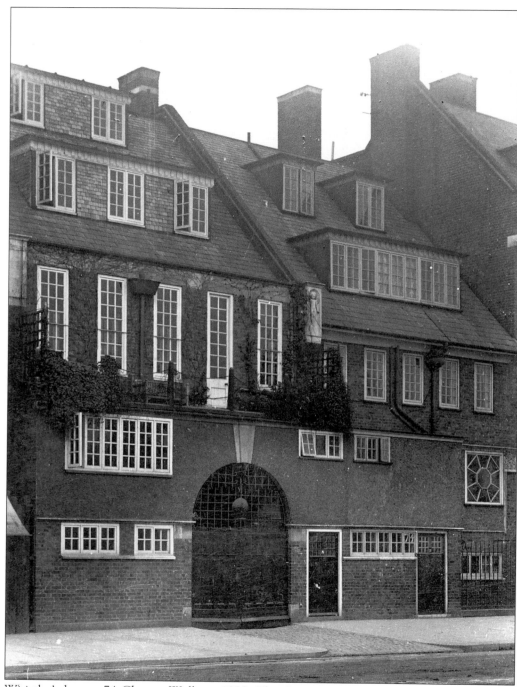

Whistler's house, 74 Cheyne Walk, *c.* 1920. The American artist, James McNeill Whistler, born 10 July 1834, was famous for his etchings of Thames river views, his series of *Nocturnes*, sunset and twilight scenes especially of Battersea Bridge, and of course for the painting of his mother. He lived in several properties in Chelsea and spent his last few years here, dying in 1903. Whistler was a founder member of the Chelsea Arts Club in 1891.

Turner's house, 119 Cheyne Walk, *c.* 1920. Joseph Mallord Turner (1775-1851), the great British landscape painter, moved here at the age of seventy-one. He became a bit of a recluse, even asking to be known as Mr Booth, probably after his companion, Mrs Booth. He spent his last few years being rowed across the river Thames to St Mary's church at Battersea where he would study the sunsets over the river.

George Eliot's house, 4 Cheyne Walk, *c. 1920*. George Eliot was the pen name of Mary Ann Evans (1819-1880), author of *The Mill on the Floss* and *Middlemarch*. In May 1880 she married John W. Cross, formerly her business adviser, and moved to Chelsea on 3 December. She died three weeks later.

The Queen's House, 16 Cheyne Walk, *c.* 1920. The title 'Queen's House' was only given in 1882 by the Revd H.R. Haweis (died 1901). The monogram 'CR' on the wrought iron railings was mistakenly thought to refer to Charles II's wife, Catherine of Braganza, but has since been proved to be for Richard Chapman, the lessee in 1717 when the house was built. This was the home from 1862 of the founding father of the Pre-Raphaelite movement in Britain, Dante Gabriel Rossetti. He lived here until his death in 1882. Algernon Swinburne, the poet, and George Meridith, the novelist, lived here for a while with Rossetti. Rossetti kept his own zoo at the house, which comprised a wombat, peacocks, armadillos, squirrels, mice, two owls and a racoon.

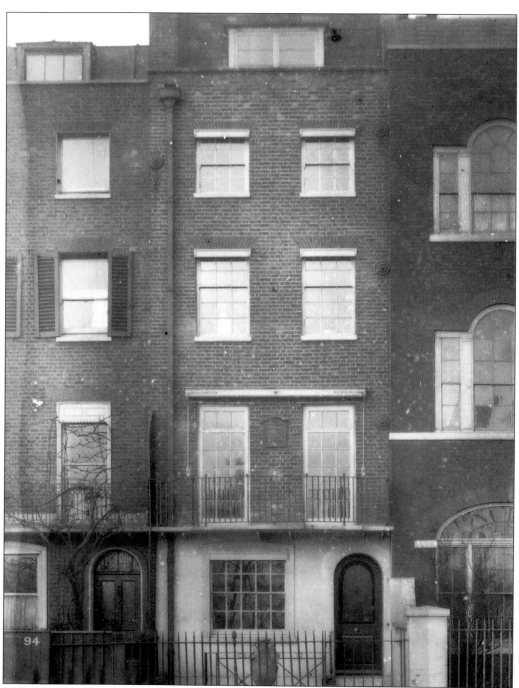

Mrs Gaskell's house, 93 Cheyne Walk, c. 1920. The house, dating from 1777, is where Elizabeth Cleghorn Stevenson was born on 17 September 1810. Her mother died within weeks of the birth and the family moved to Cheshire. In later life the young girl became Mrs Gaskell and author of *Cranford* and *Mary Barton: A Tale of Manchester Life*, a raw picture of life in millwork in the 1840s.

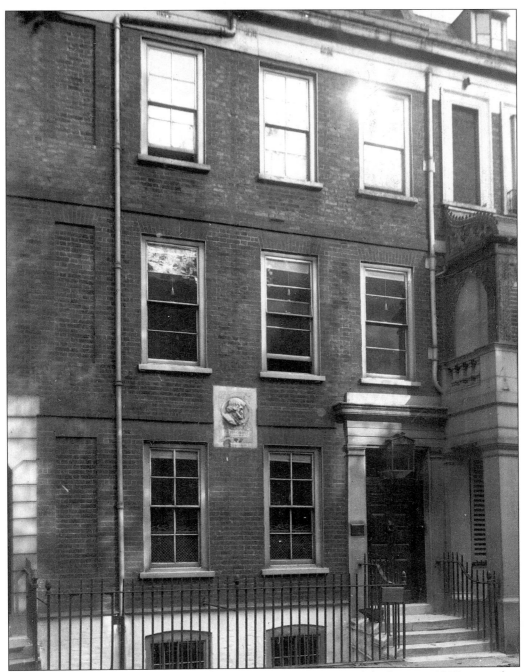

Thomas Carlyle's house, 24 Cheyne Row, *c*. 1920. Thomas Carlyle, born in 1795, moved to Cheyne Row in 1834 where he completed his three-volume work entitled *The French Revolution*. He went on to produce histories of Oliver Cromwell, Frederick the Great and the work *On Heroes, Hero-worship and the Heroic in History*. He died in this house in 1881, which in 1895 was purchased for the nation. In 1936 the National Trust took it over, and it is now a museum to the man's work.

The Clock House, 2 Chelsea Embankment, *c.* 1920. Designed by Norman T. Shaw RA in his 'Queen Anne' style, it was built in 1879 after the recent laying out of the embankment at Chelsea. He was also responsible for the nearby Old Swan House, Cheyne House and nos 9, 10 and 11 Chelsea Embankment and is more widely known for his designs of the Scotland Yard police headquarters at Westminster.

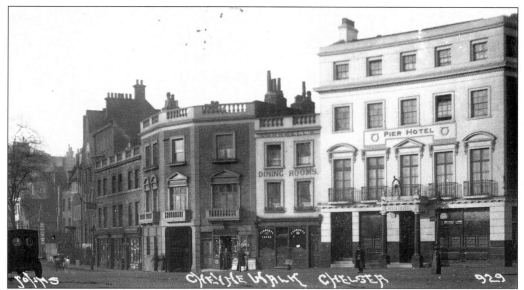

Cheyne Walk with Oakley Street to the right, *c*. 1925. The Pier Hotel, completed in 1844, was demolished in 1968 together with the Blue Cockatoo (the Dining Rooms in the photograph) which stood alongside. This small restaurant was much frequented by many of the literati and artists of the 1930s, '40s and '50s. The modern block, named Pier House Flats, has a bronze statue placed in front of it, facing the approach to Albert Bridge. The statue is called *Boy With Dolphin*, is dated 1975 and was designed by David Wynne.

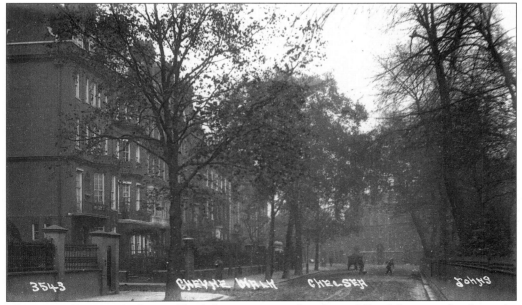

Cheyne Walk, *c*. 1920. George Eliot's house is situated in the middle of this row of eighteenth-century houses. Flood Street is to the left and Royal Hospital Road is in the far distance.

Cheyne Row, facing north from Cheyne Walk, *c.* 1914. William de Morgan, potter and artist, moved in 1872 to what is now no. 30 Cheyne Row. He started his own tile kilns here before moving to Fulham in 1887. The kiln site was later used for building the Catholic church of the Holy Redeemer. The boy on the left is standing alongside the King's Head and Six Bells public house. Originally dating from the seventeenth century, it was rebuilt in 1886.

Cheyne Row, facing south from Upper Cheyne Row, *c.* 1914. On the left is the Catholic church of the Holy Redeemer and further along at no. 24 is Thomas Carlyle's house.

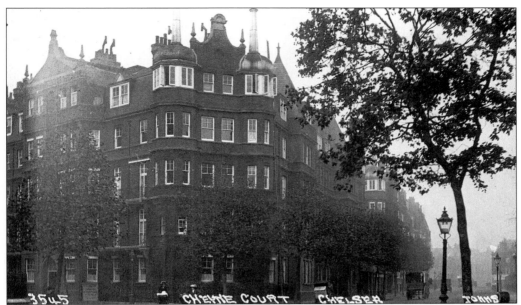

Cheyne Court Mansions, *c.* 1914. The upper view of the Court is with Flood Street on the left and Royal Hospital Road on the right. The lower scene was taken from Flood Street with Robinson Street on the left. The tall pinnacles, probably constructed of wood and covered in lead, on the roof of the corner turrets have been removed since the photograph was taken.

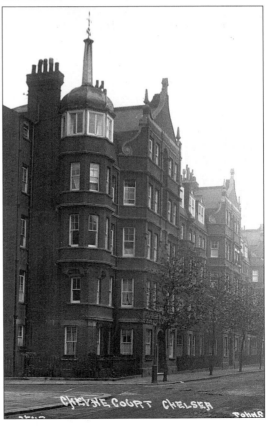

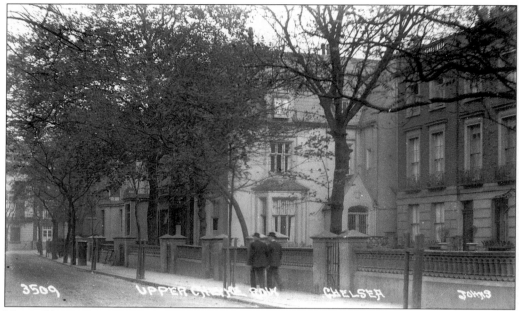

Upper Cheyne Row, *c.* 1925. The houses in Cheyne Row and in Upper Cheyne Row were built in around 1716 by a Mr Francis Cook. The writer Leigh Hunt lived at no. 22 from 1833 to 1844; a blue plaque has been affixed to record this.

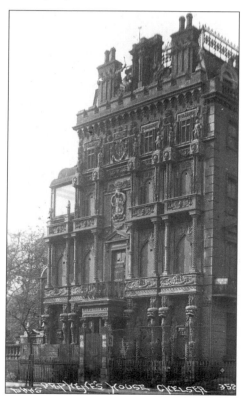

Doctor Phene's house, Upper Cheyne Row, *c.* 1912. The English admire eccentrics and amongst the greatest was Dr Samuel Phene (1823-1912). His house was built in 1901 as a conventional four-storey terrace but he added a fantastic array of architectural features. Amongst them were dragons, columns, busts, armorial bearings and capitals, all painted in brilliant yellow, gold, chocolate, bright reds and many other colours. Dr Phene's interest in genealogy had brought him to the conclusion that his family ancestry could be traced back to the Phoenicians and even to Troy. He embellished the house with his proof of this lineage; the wording above the doorway read 'Renaissance Du Château de Savenay'. He actually lived at no 32 Oakley Street while his more conventional developments were built in Chelsea. The strange-looking house was demolished in 1924.

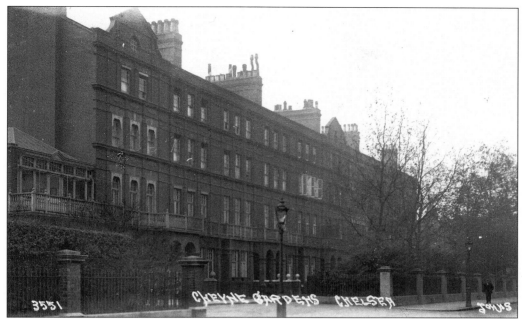

Cheyne Gardens, *c.* 1914. This fine red-brick terrace is situated on the west side of Cheyne Gardens. An almost identical terrace is on the east side opposite.

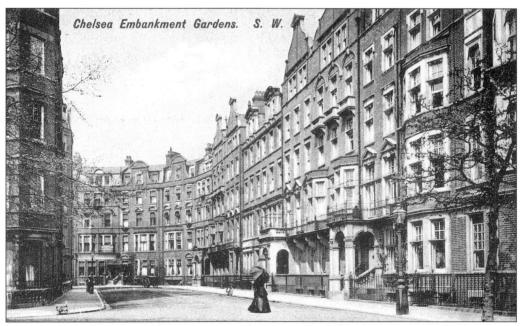

Chelsea Embankment Gardens, *c.* 1905. These apartment blocks were built in the 1890s, following the release of land for development by the Board of Works after completion in 1874 of the embankment river wall. A.A. Milne, author of the Christopher Robin series of books, lived here before 1920.

31

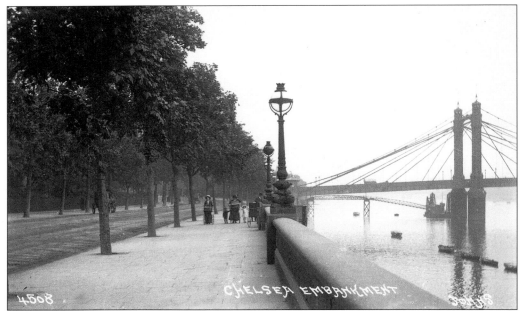

Chelsea Embankment, *c.* 1912, with the Albert Bridge and Cadogan Pier in the background. The embankment at Chelsea, from the Royal Hospital to Battersea Bridge, was officially opened on 9 May 1874 by the Duke and Duchess of Edinburgh. The section of embankment from Millbank to Chelsea was completed in 1871 and terminated in a cul-de-sac at the western end of the Royal Hospital.

Chelsea Embankment, *c.* 1912. Cheyne Walk and Oakley Street are to the left. Several early motor taxis are waiting for hire on the right at the foot of the Albert Bridge. The embankment at Chelsea was built by the Metropolitan Board of Works between 1871 and completion in 1874 under the direction of the MBW engineer Joseph Bazalgette.

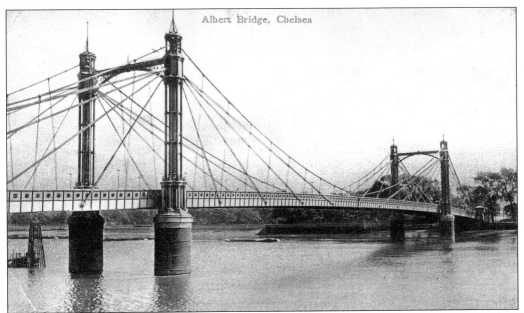

Albert Bridge, Chelsea

The Albert Bridge, above *c.* 1905 and below *c.* 1912. The bridge was designed by R.M. Ordish, opened in September 1873 and cost an estimated £90,000. Due to age and stress a central support was added to the main span between 1971 and 1973. A notice appears at either end of the bridge to the effect that marching troops must break step; the vibrations from their combined step could bring the bridge down.

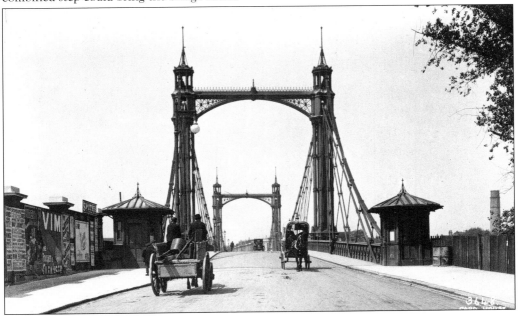

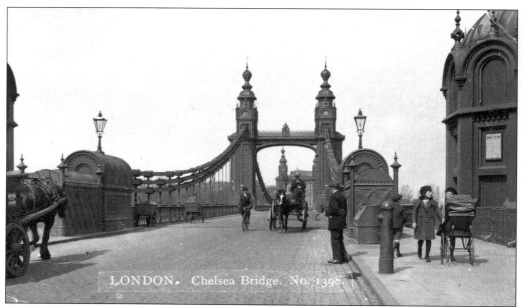

LONDON. Chelsea Bridge. No. 1398.

Chelsea Bridge, *c.* 1915 (above) and *c.* 1939 (below). The original Chelsea Bridge was built between 1851 and 1858 at a cost of £85,319 and was opened to traffic by Queen Victoria on 28 March 1858. The bridge was constructed to connect with Battersea Park, which the Queen opened on the same occasion. There were four lodge houses, two at either end, for the use of the toll-collectors; one can be seen on the right in the upper view. The bridge was freed of tolls on 24 May 1879 (Queen Victoria's birthday) by the Prince of Wales. The old bridge was removed in 1935 and the new bridge, designed by G. Topham Forrest and E.P. Wheeler and costing £480,000, was opened on 6 May 1937 by the Rt Hon. W.L. Mackensie-King CMG, Prime Minister of Canada.

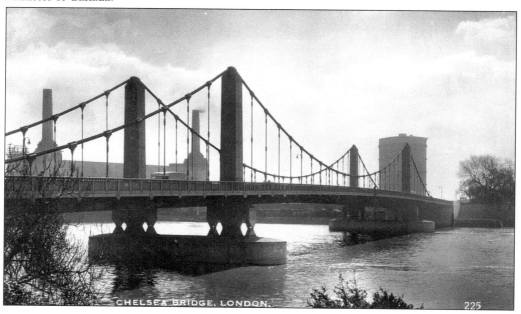

CHELSEA BRIDGE, LONDON.

225

Two
King's Road

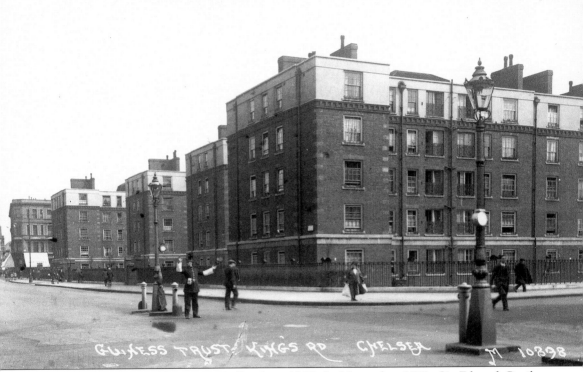

The Guinness Trust Buildings, King's Road, *c*. 1930. In November 1889, Sir Edward Cecil Guinness donated £250,000 towards providing better housing conditions for the poorer working class of Dublin and London. The Guinness Trust allocated £200,000 to London and soon commenced building of their estates. Sir Edward was created Lord Iveagh in 1891. The Mayor of Chelsea approached the Trust in 1927 with the offer of the site at Edith Grove and King's Road, on a 999-year lease at one shilling per year rent. The 160 housing units, all self-contained flats with combined bathroom and scullery, were built in 1929, solely for the working class of those living in Chelsea. The policeman is on point duty, directing traffic across this busy road junction. The point had to be manned each day for eighteen or twenty hours, several men taking on the duty. On 23 February 1944, four bombs fell in the area, one bringing down a wing of the Guinness flats which killed 86 and injured 111, during the so-called 'Mini Blitz'. The superintendent and his wife were among the casualties. A George Cross was awarded to a chimney sweep, Anthony Smith, for his efforts in rescuing several people from the wreckage of what was the worst bombing incident in Chelsea. The bombing destroyed eighty of the dwellings and damaged the others. Reconstruction of the estate was undertaken in 1947-48.

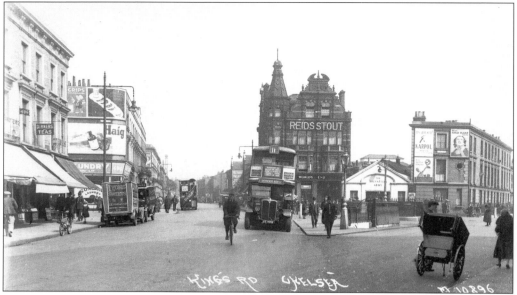

The World's End, King's Road, *c.* 1930. To those travelling through Chelsea in the eighteenth century, the World's End public house at the edge of the fields and just beyond the expanse of the Thames mud, must have seemed aptly named. Blantyre Street, to the right, was totally demolished, together with Riley, Luna and Seaton Streets in the 1960s to make way for the local authority's high-rise housing estate, which has borrowed the title of the famous pub for the estate name. The small Salvation Army Citadel dating from the 1880s alongside the pub was also demolished and rebuilt within the confines of the World's End Estate.

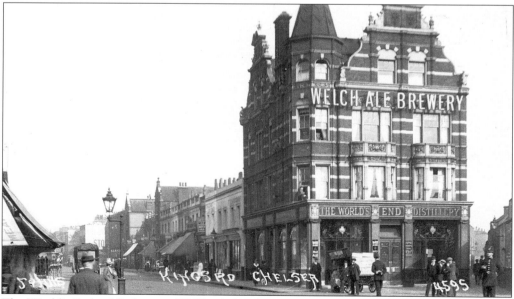

The World's End public house, 459 King's Road, *c.* 1920. World's End Passage is to the right of the pub. Along the King's Road, beyond the pub, is the parade of early nineteenth-century shops which were demolished and rebuilt at the same time as the World's End Estate was constructed.

Alexandra Mansions, King's Road, with Beaufort Street to the left, c. 1912. The shop on the left-hand corner at no. 325 King's Road was A. French's Bon Marché Boot Store. Display items were priced at 3s 11d, 4s 11d and 8s. The outlet is still selling footwear today under the name The Natural Shoe Store, but the intervening years have added a few pence to the prices!

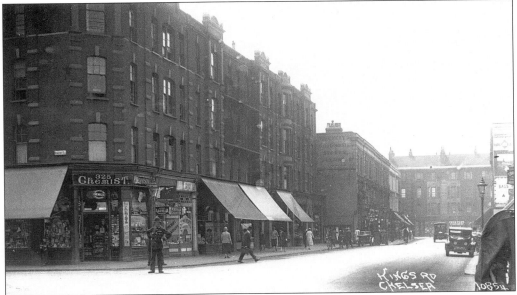

Alexandra Mansions, King's Road, c. 1933. The corner shop at no. 325 had by this time become a chemist's. The policeman, with hands on hips, appears to be searching up Beaufort Street for some traffic to direct. The three-storey terrace further along was demolished in the 1980s and a large block of shops and offices was erected; the corner block is fourteen storeys high.

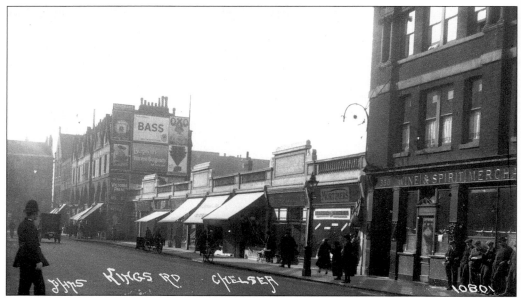

King's Road, *c.* 1933. Beaufort Street is to the right. The former public house on the right, the Roebuck, is now the Dome Café. The single-storey shopping parade (nos 356-372) now mainly houses small restaurants. At the far end is the Man in the Moon public house, on the corner of Park Walk. The three-storey block, almost ecclesiastical in appearance, now includes The Porticos luxury flats.

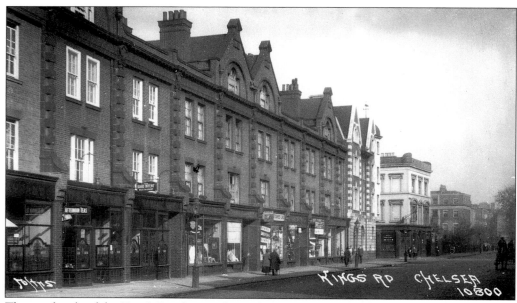

The north side of the King's Road, east of Beaufort Street, *c.* 1933. The first three outlets on the left were combined as the Good Intent restaurant. On the far corner of Old Church Street is the Cadogan Arms tavern, formerly called the Rose and Crown.

Argyll Mansions, on the south side of King's Road and the corner of Beaufort Street. The upper view is from about 1904 and the lower about 1930. The site was formerly a late eighteenth-century house in use by Dr Lee as his surgery, but this was demolished around 1903 for the mansions. The mansions were built above what has proved to be a popular parade of shops where the leases are usually keenly taken up. The King's Road was kept as a private road for the monarch to use on his way to Hampton Court but this proved a great inconvenience to the inhabitants of Chelsea. Access to the town was either along the embankment or via Church Lane, now Old Church Street. The use of the King's Road was restricted to those with specially issued tokens, very few of which could be bought. The road was eventually made public in 1830, a decision which soon brought in the property developers.

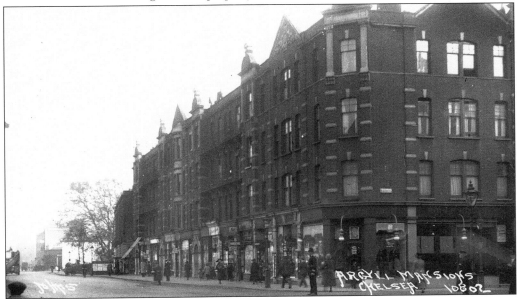

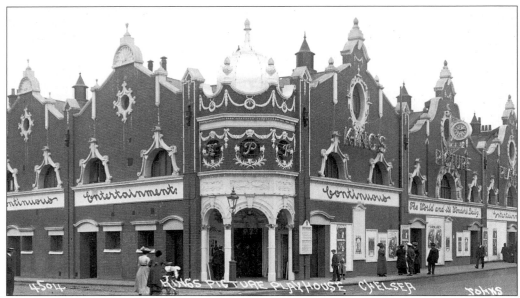

The King's Picture Playhouse, 279 King's Road, on the corner of Old Church Street, *c*. 1912. The building was originally opened as a roller-skating rink and converted into a cinema named the Palaseum in 1910. It was renamed the King's Picture Playhouse in 1911. The cinema has been refurbished and rebuilt over the years and renamed as follows: the Ritz in 1943, the Essoldo in 1949, the Curzon in 1972, the King's Road Theatre during the 1970s, the Classic in 1980 and then the Cannon Cinema. The Virgin chain of cinemas now has control.

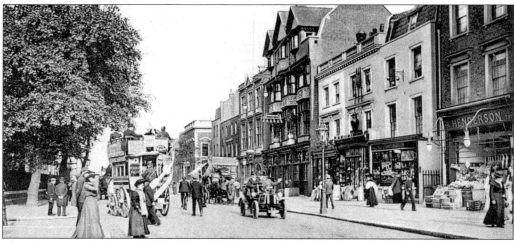

The King's Road near Sydney Street, *c*. 1905. The taller building on the right is the Six Bells public house. The original pub dated from approximately 1780 and was rebuilt in mock-Tudor style in 1900. The pub suffered during the Blitz, when on 14 October 1940 a bomb exploded in the basement killing two and injuring seven. The pub has since lost its original name and now trades as Henry J. Bean, a bar and grill. To the left of the horse-drawn bus is the old burial ground, given to the parish in 1733 by Sir Hans Sloane; the last burials there were in 1824. The grounds were laid out as a public garden in 1977 to commemorate the Queen's Silver Jubilee and the Chelsea Society's Golden Jubilee and were named Dovehouse Green. There is also a plaque 'in remembrance of the 457 civilians killed in Chelsea by enemy action, 1939-1945.'

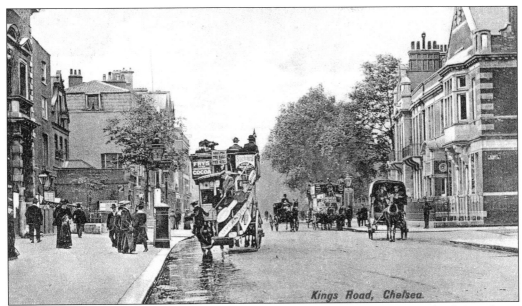

King's Road with Sydney Street to the right, *c.* 1905. In 1883 the Board of Guardians, administrators of the poor laws, erected the building on the right, no. 250 King's Road, as their administrative headquarters. It was designed by Messrs Harston. The building was enlarged in 1903 and the foundation stone for the extension was laid on 8 April 1903 by James Jeffery, LCC Chairman of Guardians. The architects were M.J. Lansdell and E.J. Harrison and construction was carried out by Charles Wall, builder. The building was later used by the Borough Council as the Registrar's office, which is now situated in the old Town Hall, opposite. The Board of Guardians' office survives as an antiques centre.

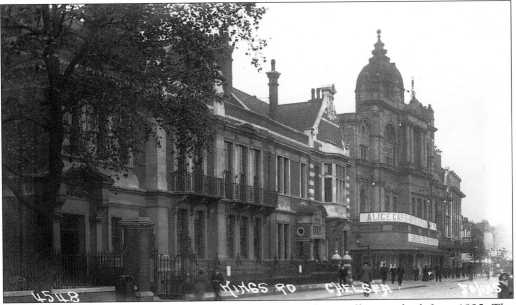

The King's Road facing east, with the old Board of Guardians' office on the left, *c.* 1925. The taller building on the far side of Sydney Street is the Chelsea Palace theatre.

41

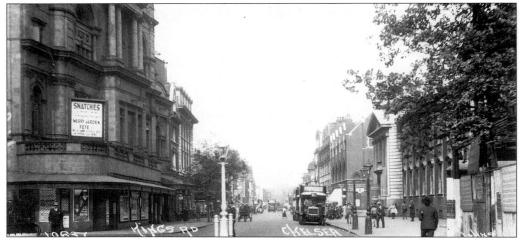

The Chelsea Palace theatre, nos 232-242 King's Road, *c.* 1928. Sydney Street is to the left and Chelsea Town Hall is to the right. The theatre, faced in terracotta, was built in 1903 with 2,500 seats. Many well-known names appeared in this music hall: Gracie Fields, George Robey, Vesta Tilley, Wee Georgie Wood and Harry Lauder. The theatre closed in 1957 and Granada Television took it over for their television productions but it was finally closed and demolished in 1960. A little further along the road today, at no. 206, is the Chelsea cinema, opened on 8 December 1934 as the Gaumont Palace. The building was partly converted into a department store in 1972 but still has 739 cinema seats. On the upper façade is a plaque to the memory of William Friese-Green (1855-1921) who invented modern celluloid movie film and patented his movie camera in 1888. At the time his laboratory was at no. 39 King's Road, Chelsea.

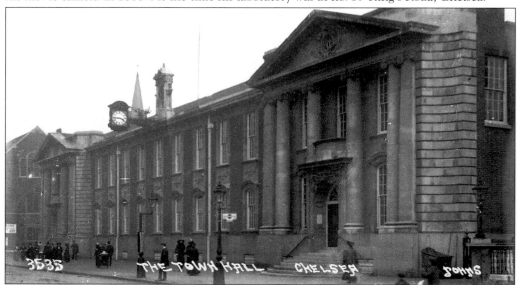

Chelsea Town Hall, King's Road, *c.* 1914. The granite and brick Town Hall was built in 1886 to the designs of J.M. Brydon and was extended between 1906 and 1908 by Leonard R. Stokes. The bracket clock on the front of the building has the Latin inscription *Tempus Fugit*. The building's duties were reduced in 1965, after the amalgamation of Chelsea with the Borough of Kensington, and now houses Chelsea library and the social services department for the area. Several halls are available for hire, notably for the many antiques fairs held here.

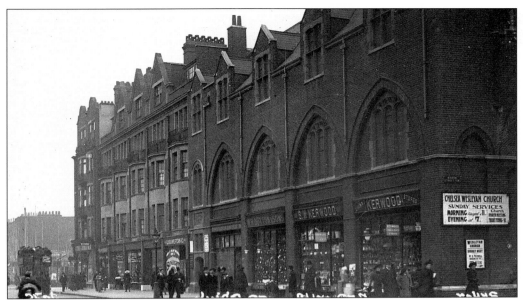

This parade of shops in the King's Road on the corner of Chelsea Manor Street was built in 1903, incorporating a Methodist church; a Methodist school was added in 1905. This view dates from around 1912. The church tower on the Chelsea Manor Street façade was destroyed during wartime bombing and the church made unfit for worship. The entrance to the church is in the middle of the shopping parade. In the 1970s the church was rebuilt and included a drop-in centre and counselling service. Twenty-one homes for the elderly were added and leased to a charitable trust.

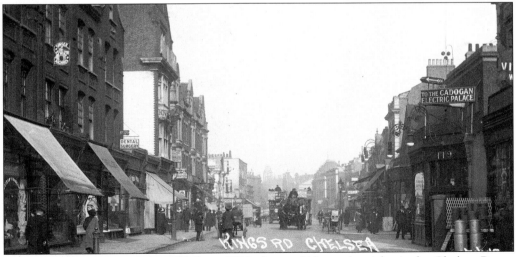

The King's Road, near Radnor Walk, *c.* 1912. At no. 119, on the right, is the Chelsea Potter public house. The pub has a direction sign above the single-storey bay roof pointing to the Cadogan Electric Palace cinema; this was at nos 180-182 King's Road, three premises west of Blenheim Street, behind the cameraman. Jubilee Place is on the left by the horse and cart. Radnor Walk commemorates the Earl of Radnor who had a large mansion, called Danvers House, in the seventeenth century. Danvers Street and Paultons Square were built subsequently on the site.

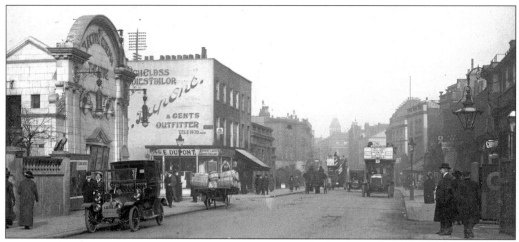

On the corner of Markham Street at nos 148-150 King's Road stands the Imperial Playhouse cinema, owned by Chelsea Estates Ltd. It is seen here about 1912. This small cinema with only 394 seats was better known in the 1960s as the Classic cinema, although the building was refaced and looked vastly different from the earlier structure. The last film was shown on 4 August 1973 and the cinema was subsequently demolished. A Boots chemists shop now occupies the site. The large motor car is parked outside the entrance to the Pheasantry that once belonged to Box Farm, built in 1686 where the cinema was later built. The last owner of the farm before its demolition in 1900 was Mr Pullam Markham Evans. Markham Square, just a little distance along the King's Road, is where the farm orchard stood.

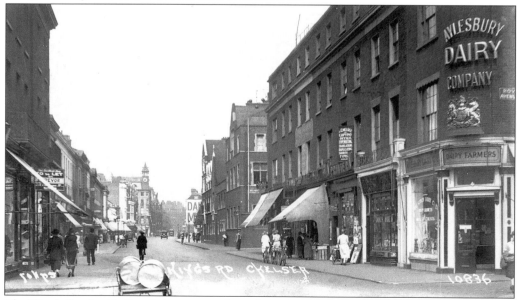

The King's Road with Royal Avenue on the right, *c.* 1930. The Aylesbury Dairy, on the corner, was one of many small dairies in the area that before the First World War would deliver milk, butter and many other dairy products as often as three times a day. The refrigerator was not in common domestic use until the 1950s and it was difficult to keep meat, fish and dairy products from decomposing. The dairies reduced delivery times from three times per day to twice daily in 1914 because of the manpower shortage.

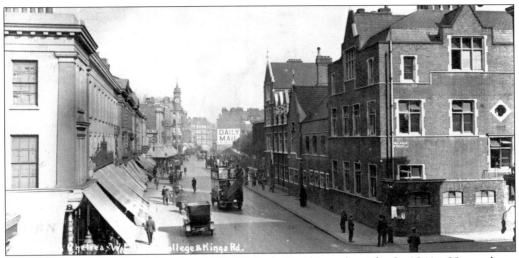

Whitelands College, King's Road, *c.* 1920. Walpole Road is to the right. In 1841 a 99-year lease was taken by the National Society for the Promotion of Education on a three-storey Georgian house in the King's Road called Whitelands House, as a women's teacher training college which opened in 1842. The Georgian house was never considered adequate for the increasing student numbers and further college buildings were added in 1850, 1890 and 1899. Whitelands House was demolished in 1891. The college chapel, dedicated to St Ursula and begun in 1881, was decorated with twelve windows of female saints, manufactured by William Morris and designed by Burn Jones. The chapel contents, including the beautiful reredos, were successfully moved when the college was relocated to Southfields, Wandsworth in 1931, where Queen Mary officiated at the opening ceremony on 1 June.

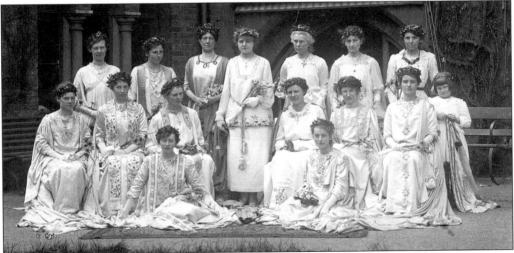

In 1881, the famous Victorian philosopher, John Ruskin, suggested a May Queen festival as part of his romantic ideal and appreciation of beauty. He gave to the college a collection of books, establishing a library including copies of paintings by Turner. Ruskin had a cross of gold made especially for the May Queen to wear and crosses of gold are presented to each new Queen. Many of the dresses, some heavily embroidered and others of parachute silk because of wartime necessity, are proudly worn by ex-Queens attending later ceremonies. The May Queen for 1919, seen here, was Queen Janet I.

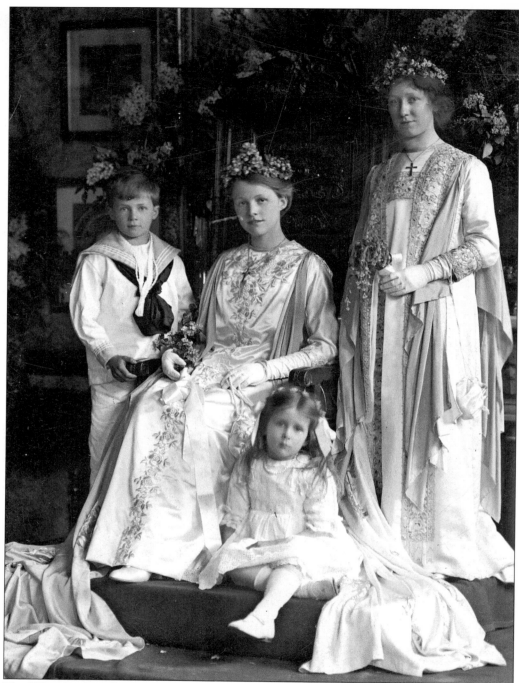

The Whitelands College May Queen in 1914 was Queen Ellen III. The dress has been preserved with several others and is on display in the new building. The dress is decorated with heavy cream roses. The college first took male students in 1966 and it was quickly realised that restricting the ceremony to females was no longer possible. May Kings have been elected since 1986.

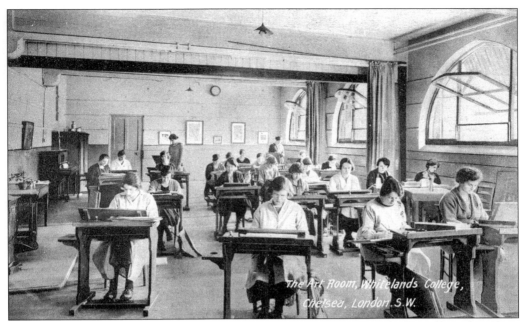

The art room at Whitelands College, *c.* 1925. The student teachers had needlework and art lessons as part of their curriculum. Before the First World War, a drill instructor from the neighbouring York barracks would instil in the ladies the usefulness of Swedish gymnastics. The daily routine in the 1850s started between 6 and 7 a.m. and finished with lights out at 9.30 p.m.

Blacklands Terrace is to the left of this parade of shops on the King's Road, seen about 1930. To the left is the Freeman Hardy and Willis shoe shop and F.W. Woolworth's 3d & 6d stores. The far end of the parade, nos 34-50 King's Road, was built in 1887.

The Peter Jones department store, King's Road, c. 1928. After taking up nos 4 and 6 King's Road in 1877, by 1884 Peter Jones had bought up twelve adjoining shops and had decided to rebuild in grand style. The lovely old store of red brick and stonework survived until a new store of steel, pink and green glass was erected in 1932 to the designs of William Crabtree.

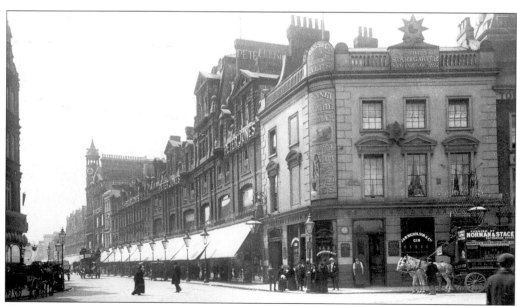

The Peter Jones department store, c. 1905. The Star and Garter public house, on the corner of Sloane Square at no. 26, was demolished to make way for the 1932 enlargement of Peter Jones department store, which since 1906 has been part of the John Lewis group of stores.

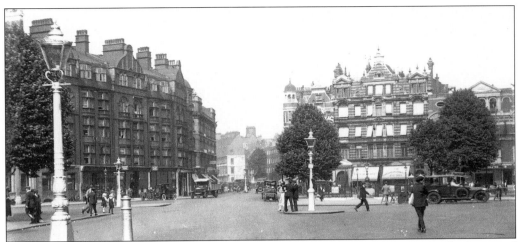

Sloane Square, *c*. 1925. Beyond the tree on the right is the Royal Court theatre which opened in 1888 next to Sloane Square Underground station, itself opened on 24 December 1868. The theatre's productions and finances have been both high and low but particularly well-patronised shows before the First World War included plays by Bernard Shaw, and since the 1950s plays by Harold Pinter, John Osborne and Samuel Beckett. The theatre suffered greatly in the air raid on Sloane Square station on 12 November 1940 when thirty were killed and fifty injured. The theatre was rebuilt and reopened on 2 July 1952 and the station was reopened on 3 May 1951, to be ready in time for the opening of the 1951 Festival Gardens at Battersea Park, this being the nearest Tube station.

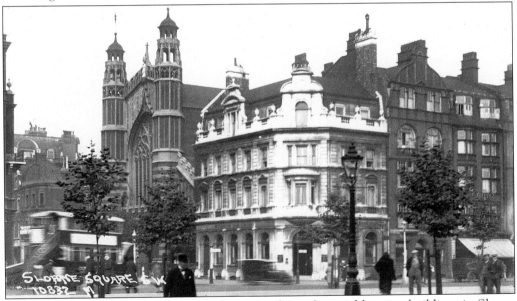

The twin towers of Holy Trinity church rise up above the neighbouring buildings in Sloane Street near the junction with Sloane Square, *c*. 1930. The original church of 1830, designed by John Savage, was deemed unsatisfactory and the present church, built to the designs of J.D. Sedding, was consecrated on 13 May 1890. The large east window is by Edward Burne-Jones and was made in the William Morris factory. The interior is decorated with marble and semi-precious stones.

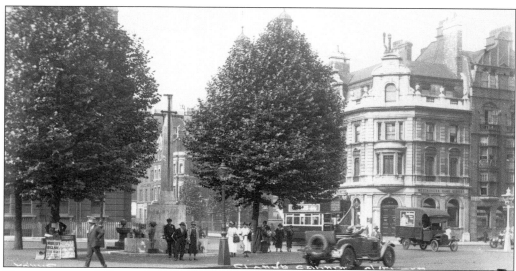

The war memorial, Sloane Square, *c.* 1928. The war memorial was dedicated on Sunday 24 October 1920 by Field Marshal Sir William Robertson. A party of the 2nd Battalion Coldstream Guards with a band from Chelsea barracks were present. The Territorial Army, cadet corps, nurses and ambulance corps were represented. The Archdeacon of Middlesex conducted the devotional part of the service. Lord Asquith and Sir S. Hoare MP attended the unveiling, witnessed by an enormous crowd. The memorial, designed by Sir Reginald Blomfield RA, was paid for by public subscription from the people of Chelsea. The subs were collected by Miss LW Kempson at the South Western Polytechnic, Manresa Road. The original proposal in 1919 was to erect the 24ft tall memorial at the southern end of Royal Avenue. The dedication reads: 'In memory of the men and women of Chelsea who gave their lives in the Great War 1914-1918 and 1939-1945'. The memorial has since been moved to the east side of Sloane Square. The five-storey block in the background, in the lower view, is Cadogan Mansions, built in 1895 by the Cadogan Estate Management Company.

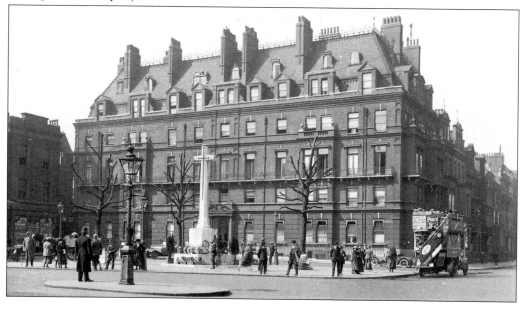

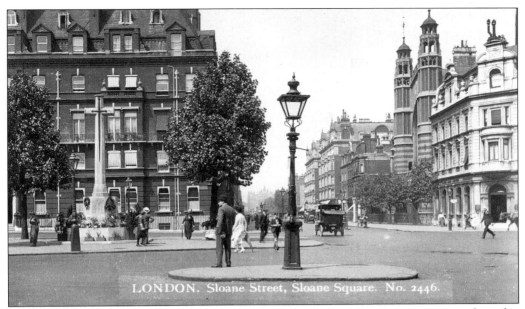

Sloane Street from Sloane Square, *c.* 1928. Holy Trinity church is most prominent on the right.

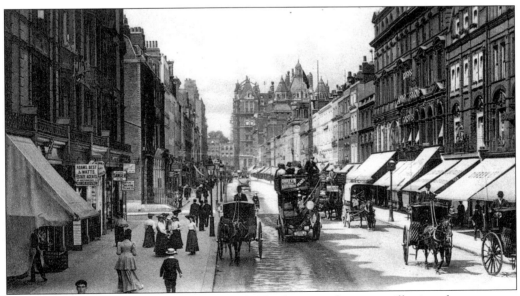

The northern part of Sloane Street, *c.* 1905. The horse at this time still reigned supreme on London's roads. For those wishing to cross the road on foot, an eye had to be kept out for the deposits left by the horse traffic. Virtually all of these buildings were demolished and replaced during the 1930s and after the Second World War.

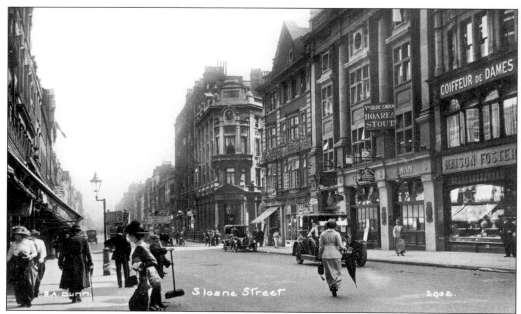

The view facing south along Sloane Street, *c.* 1914. On the right at nos 3 and 4 is the Old Swan public house. The hair-dressing salon of Maison Foster occupies no 2 Sloane Street, on the right. Basil Street is further down the road beyond the second motor car.

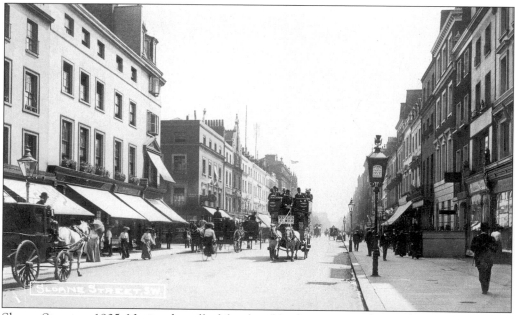

Sloane Street, *c.* 1905. Notice that all of the shop blinds are out on the south-facing side of the road to protect the goods on display in the shop windows from discolouring through exposure to the sunlight. The parades of Victorian shops on both sides have been demolished; on the left is now a fourteen-storey block of apartments. Harriet Street is to the left.

Three
Streets South of King's Road

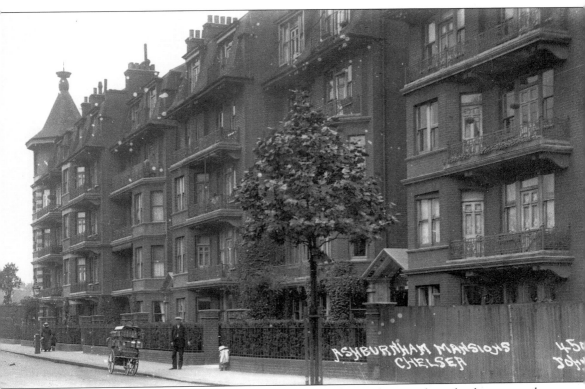

Ashburnham Mansions, Ashburnham Road, c. 1914. The house that stood nearby, later named Ashburnham House, was built in 1747 for a Dr Benjamin Hoadley. Lady Mary Cloke moved here from Kensington in 1788. The Earl of Ashburnham lived here up to 1862 when the house was converted for use as a pleasure garden as part of Cremorne Gardens. The architect for Ashburnham Mansions was J.A. Gillknight ARIBA. The mansions were almost cut in half on Friday 18 October 1940 by a high explosive bomb that levelled the central wing, blocking the roadway in front.

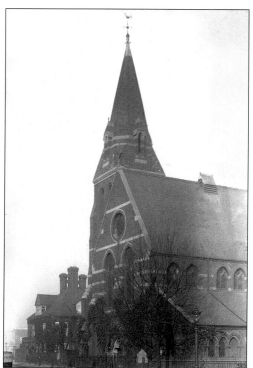

St John's church, seen here about 1914, stood on the corner of Ashburnham Road and Tadema Road. The church was consecrated in 1876 and destroyed by bombing in 1940. The site was later used for housing and the congregation moved to St John's mission hall, Blantyre Street, built in 1875. A new church was built on the World's End estate, near the World's End pub and fronting onto the King's Road, named St John's and St Andrew's.

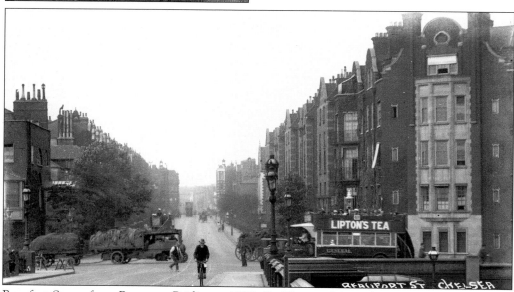

Beaufort Street from Battersea Bridge. *c.* 1928. Sir Thomas More's house stood almost where Beaufort Street was laid out. The house was altered and enlarged over the following two hundred years. After the Civil War, the house came into the ownership of Henry, Marquess of Worcester. When he gained the title 1st Duke of Beaufort, the house also gained the name. The first duke lived here from 1682 until 1699 and the Beauforts moved out in 1736, the house being demolished about 1740. The building on the left corner, Belle Vue Lodge, no. 91 Cheyne Walk, is where Luke Thomas Flood lived in 1829. (See also p. 63)

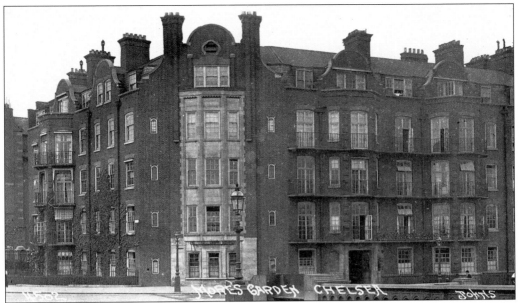

More's Garden, a block of flats on the corner of Beaufort Street and Cheyne Walk, *c.* 1912. The house of Sir Thomas More had gardens that reached southwards almost to the River Thames and eastwards to where Crosby Hall now stands. This large block of flats, overlooking the river, commemorates the former gardens.

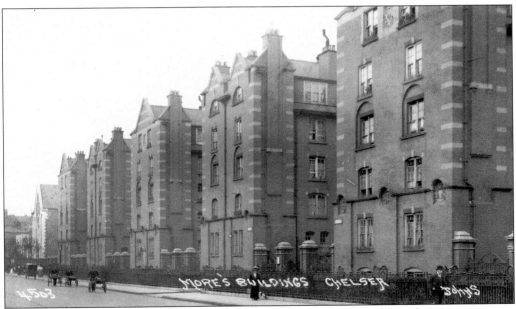

More's Buildings, Beaufort Street, *c.* 1920. The Sir Thomas More Buildings housing estate was erected in 1903/04 by the Metropolitan Borough of Chelsea. The architects were Joseph Smithem and the builders were Charles Wall Ltd. The mayor for that year was Major W. Fountain Woods. The five blocks are named Kingsley House, Burleigh House, Dacre House, Winchester House and Cadogan House, all associated with the Manor of Chelsea.

Beaufort Mansions, Beaufort Street, *c.* 1912. In the distance, near the King's Road, is a London County Council tram on route 34. Beaufort Street was the only one in Chelsea to ever have trams; they were introduced on 22 June 1911 and continued in use until 16 March 1950 when Battersea Bridge was damaged by the collier *John Hopkinson* and the tramway service had to be withdrawn.

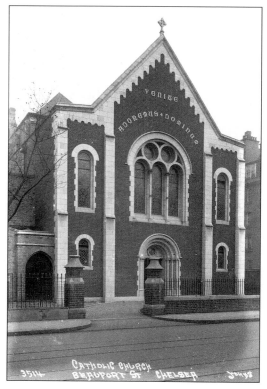

The Convent of Adoration Reparatrice and Catholic church, Beaufort Street, *c.* 1914. The church was bombed in 1940 and a gaping hole was left open until rebuilding in the 1950s. The church is named after St Thomas More, who was beatified in 1935. The nuns pray each day for England to be returned to the Catholic faith.

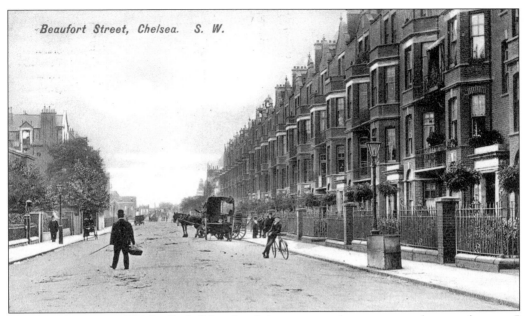

Beaufort Street, *c.* 1905. Mrs Gaskell lived with her parents when young at what was then no. 7 Beaufort Street.

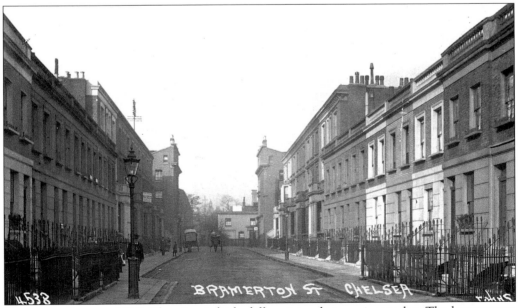

Bramerton Street *c.* 1912. The view is little different to what survives today. The houses were built on land formerly part of the Rectory kitchen garden, leased out in 1870 for building purposes by the rector. The southern end was called Caledonian Terrace and had been built between 1830 and 1860. The road name was changed in 1878 when the northern part was under construction between 1877 and 1879.

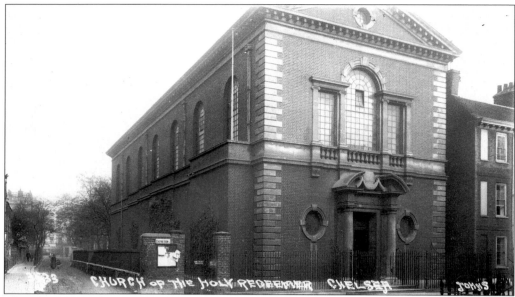

Church of the Holy Redeemer, Cheyne Row, *c*. 1914. The potter and artist William de Morgan moved to no. 8 Cheyne Row in 1872 and leased the Orange House to expand his business. In 1887 he moved to larger premises in Fulham. The site became available in the 1890s for Roman Catholics to build a church. Designed by Edward Goldie, the church was ready for worship in 1905 and dedicated to Our Most Holy Redeemer. After elevation to sainthood in 1935, Sir Thomas More's name was added to the title. On 14 September 1940, eighty people were sheltering in the crypt and basement of the church when it was struck by a high explosive bomb, causing many casualties and injuries.

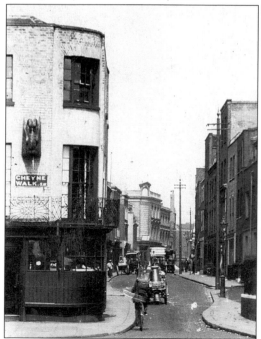

Church Street, *c*. 1922. The old parish church is on the right. The eighteenth-century building on the left survived as a doll and toy shop until demolition in the early 1930s, which included the neighbouring Lombard Café. This name harked back to the time before the embankment was built in the 1870s when this stretch of waterside was called Lombard Street.

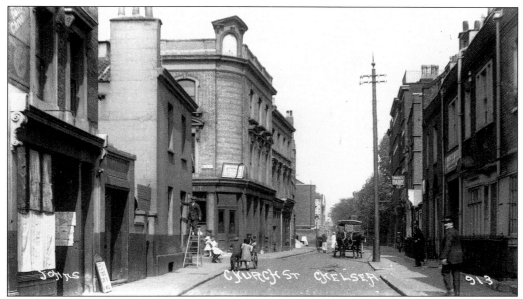

Church Street, *c*. 1922. The three-storey building was the Black Lion public house, originally dating from the seventeenth century and rebuilt in the late Victorian era. The pub was renamed in 1986 the Front Page, part of a small group of pubs in London that now have a newspaper theme. On the right by the telegraph pole at no. 46 was Wright's Dairy, whose terracotta cow still looks down from the second floor frontage. A second terracotta cow survives in the access yard alongside. Poultons Street is to the left of the group of children.

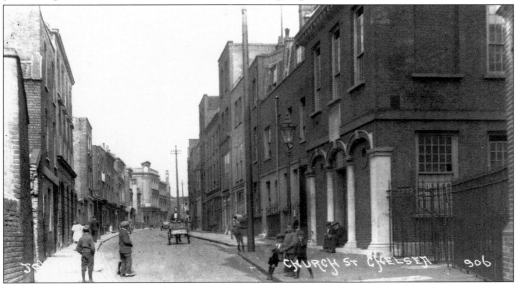

Church Street, *c*.1922. The building on the right was the Church House and Sunday school, a replica of the Petyt parish school which stood from soon after 1705 until 1890. William Petyt, keeper of records at the Tower of London, rebuilt the school at his own expense. The building was also used as the Parish Vestry Room. Rebuilt in the 1890s, it was destroyed in the bombing incident of April 1941 when the parish church alongside was also destroyed. A new parish centre has been built on the site and named Petyt House.

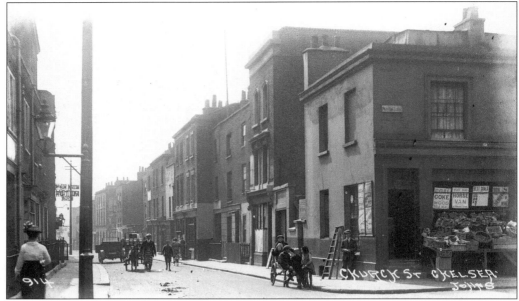

Church Street, *c.* 1922. Poultons Street is on the right. The buildings have hardly altered over the years, except that some of the shop fronts have gone with the alteration of properties into private domestic homes. The railings have been removed and some of the architectural features, such as cement rendering, have been added or deleted.

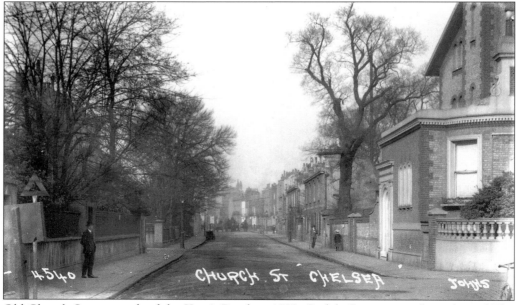

Old Church Street, north of the King's Road, *c.* 1922. Carlyle Square is to the right and Elm Park Road is to the left of the lamp-post. Number 127, on the corner of Elm Park Road, has a blue plaque in memory of the master potter and artist, William de Morgan and his wife Evelyn de Morgan, who lived here. William died there in 1917.

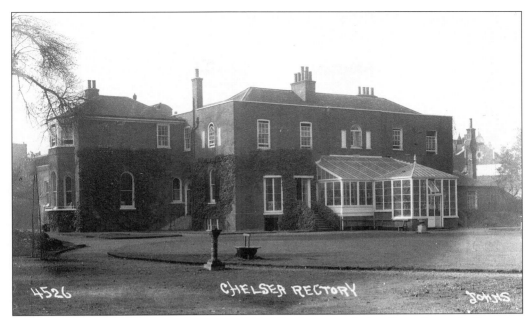

Chelsea Rectory, Old Church Street, *c.* 1914. The Rectory, dating from the early Georgian period, stands in two acres of gardens near to the King's Road. A mulberry tree in the garden is reputed to have been planted by Queen Elizabeth I. The Duke of Wellington sat beneath the tree conversing with the then rector, his brother, the Hon. G.V. Wellesley. The Rectory and grounds were sold off for private development in the 1980s.

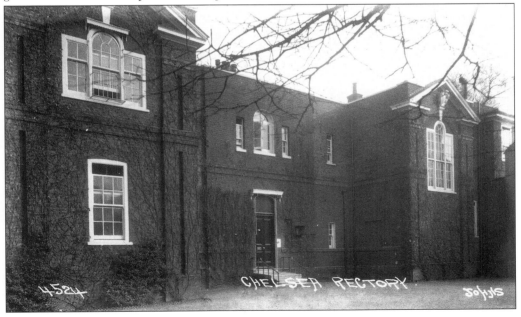

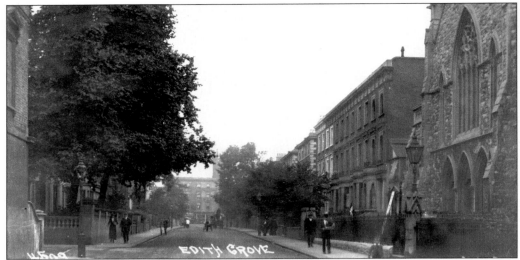

Edith Grove, *c.* 1914. The road is named after Edith Gunter, daughter of the developer of what had previously been market gardens. The father, James Gunter, a successful Mayfair confectioner, had started purchasing land in 1801, in the area west of Drayton Gardens, south of Old Brompton Road, extending west to Brompton cemetery and south to Fulham Road. James Gunter died in 1819, leaving the estate to his son, Robert, who commenced development of the land on the northern boundaries in the 1840s. The major building works from 1850 for the next twenty-five years started in the east and extended to the west. Robert Gunter died in 1852; he had two sons. The eldest, also Robert, was born in 1831 and James, born in 1833, continued the expansion of the development.

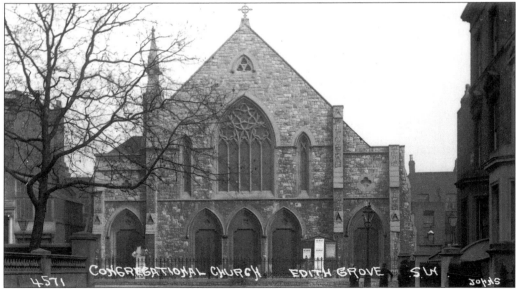

The Congregational church, Edith Grove, *c.* 1914. The church was opened in 1867 as the West Brompton Congregational church but was destroyed by bombing during the Second World War. The church was rebuilt in 1954 and in 1960 was renamed the Chelsea Congregational church and from 1972 to 1988 was the United Reformed church. The Baptists joined the congregation in November 1988 and today it is a non-conformist centre for worship.

62

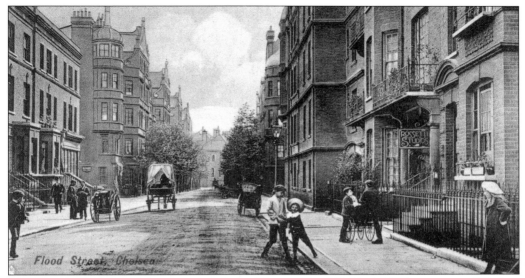

Flood Street, *c.* 1905. The street is named after Thomas Flood JP (died 1860), treasurer of Chelsea Parish School in Old Church Street. He funded many of the poorer children, providing bread, clothing and payments for apprenticeships and for increased academic achievement. The Rossetti Studios, now no. 70 Flood Street on the right, were erected by Edward Holland in 1894. The studios are actually at the rear of no. 70 and reached through an archway. Margaret Thatcher lived at no. 19 Flood Street, even for a few years after becoming the Prime Minister. In the period 1928-1930, William James Joyce ('Lord Haw-Haw') was a member of the Chelsea branch of the Conservative party; he lived in Flood Street at the time with his first wife, before leaving for Germany to make his infamous wartime radio broadcasts.

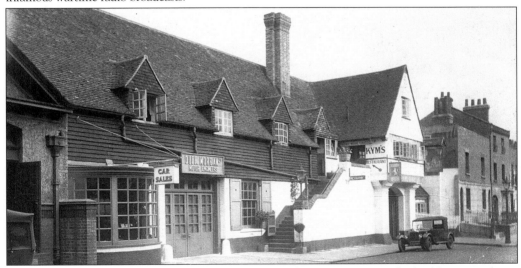

The Duff Morgan garage and Kym's Restaurant, Flood Street, *c.* 1930. The building now forms part of the 'Antiquarious' antiques showroom, which has its main entrance, a former Temperance billiard and snooker hall, in the King's Road, at no. 135. The upper floor, once Kym's restaurant, is now a private residence, whereas the doorway by the motor car is now the entrance to the Antiquarious Café. The properties to the right were demolished around 1936/37 and the present houses went on sale in 1938.

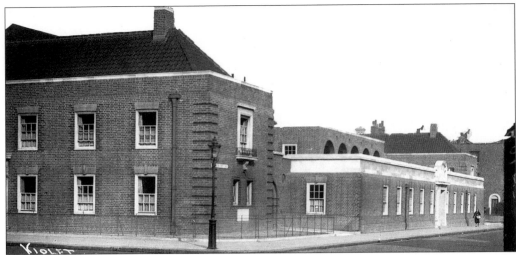

The Violet Melchett welfare centre in Flood Walk, at the rear of the Town Hall, *c.* 1933. The foundation stone for the welfare centre was laid by Lady Melchett DBE on 25 June 1930 and was opened by Queen Mary on Thursday 26 March 1931 with a golden key presented by the architect, Mr F.J. Buckland. The centre still administers to expectant mothers, carrying out ante-natal and post-natal inspections, offering infants medical inspections and also providing a day nursery for the children. Sir Alfred Mond, Minister of Health in the 1920s, was elevated to the peerage in 1928 and took the title Lord Melchett; he unfortunately died on 27 December 1930, shortly before the centre was opened.

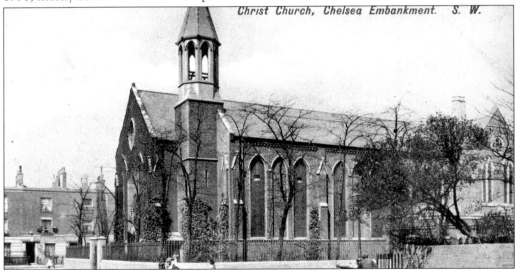

Christ Church, Caversham Street, *c.* 1905. The church, built to the designs of Edward Blore and costing just over £4,000, was consecrated on 26 June 1839. The costs were borne by the Hydman Trust, which was concerned with the spiritual well-being of the newly emerging working class. The church was fortunate in acquiring an organ built by England and Russel in 1779 and a pulpit in the character of the wood carver Grinling Gibbons (1648-1721) in 1876, after the demolition of some City churches for the construction of Queen Victoria Street. A new west front, designed by W.D. Caroe, was added before the First World War and a new entrance porch by G.G. Woodward was built in 1933.

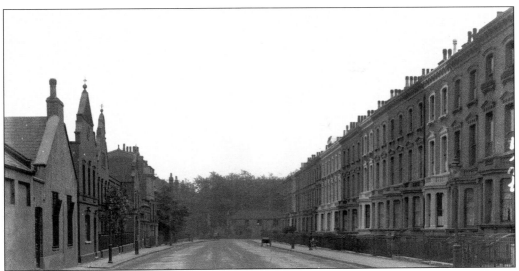

Glebe Place, *c.* 1914. The land here formed part of the Rectory kitchen gardens, which was released for building development in an act dated 1870. The architect, Philip Webb, designed an early version of the Victorian 'Queen Anne' style of houses for George Pryce Boyce, which was built in Glebe Place in 1868. The Scottish architect Charles Rennie Mackintosh and his wife had adjoining studios at nos 43a and 45 from August 1915 to 1923. The couple designed several studios in Chelsea but only one was ever built and that was no. 49 Glebe Place, for the painter Harold Squire. John Galsworthy (1867-1933), novelist and playwright, remembered for the *Forsyte Saga*, lived at Cedar Studios which was later the home of the author John Osborne, given the sobriquet 'angry young man' for his play, *Look Back in Anger*, published in 1956.

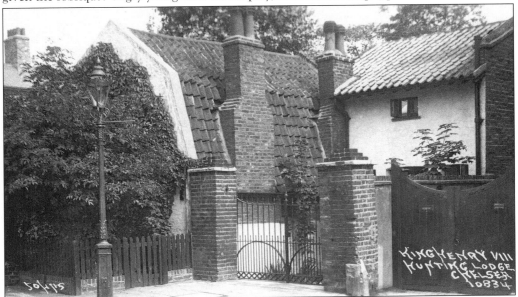

King Henry VIII hunting lodge, Glebe Place, *c.* 1920. The name of the house is far too early for its construction, which probably dates from the seventeenth century. The King certainly did own the Manor of Chelsea in 1536, but had his mansion built near to where Oakley Street meets Cheyne Walk. The lodge has been in use as a kindergarten for some years.

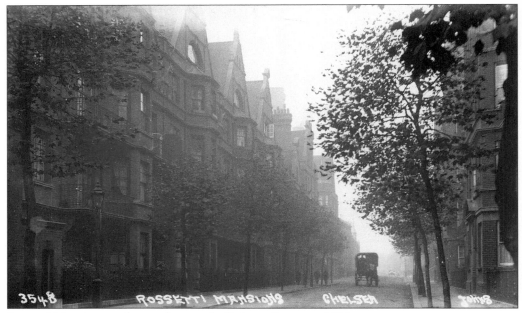

Rossetti Mansions at the southern end of Manor Street, *c.* 1914.

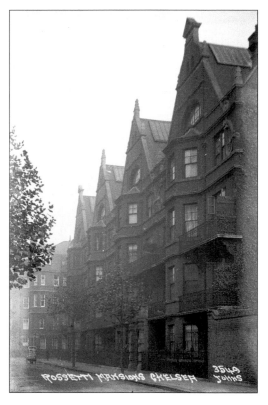

Rossetti Mansions, *c.* 1914.

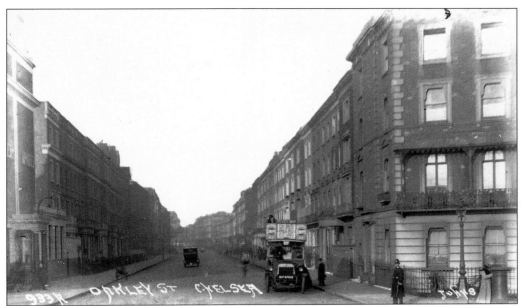

Oakley Street, facing north from Cheyne Walk, near the approach to Albert Bridge, *c.* 1922. In 1753, when Sir Hans Sloane died, Chelsea Manor was divided between his two daughters. In 1717 Elizabeth had married Charles, 2nd Baron Cadogan of Oakley. Oakley is a small village in Buckinghamshire. The playwright Oscar Wilde's widowed mother moved to no. 46 (renumbered 87 but now demolished) in 1876. Dr Phene, who built the mock château in Upper Cheyne Row (see p. 30), lived at no. 32 Oakley Street.

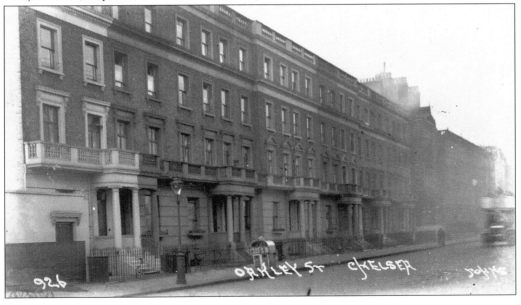

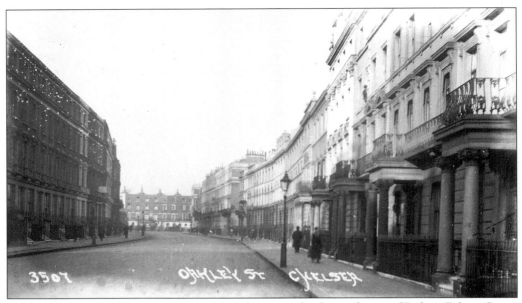

Oakley Street, *c.* 1905. At no. 56 is a blue plaque on the former home of Robert Falcon Scott, whose epic attempt in 1912 to return from the South Pole in which he and his companions perished, has become part of the British psyche.

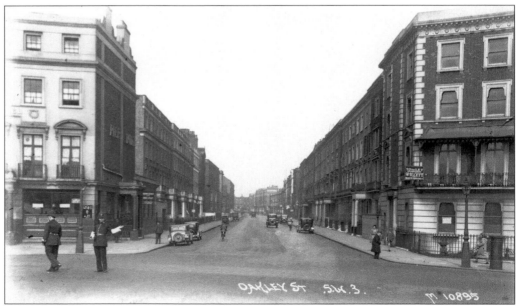

Oakley Street, *c.* 1933. The Pier Hotel is to the left.

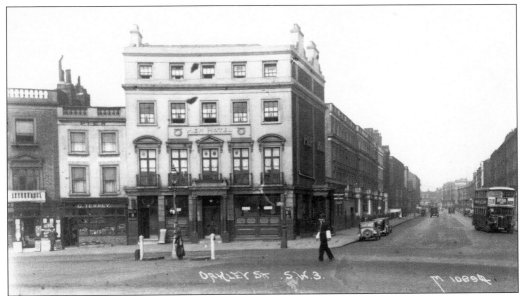

Oakley Street from the approach to Albert Bridge, *c.* 1933. The policeman on point duty has left his cape hanging from the lamp standard on the left. What is noticeable is the attempt with the Pier Hotel and adjoining shops on the left to emulate the curve of the terrace on the eastern side designed by Pennethorne.

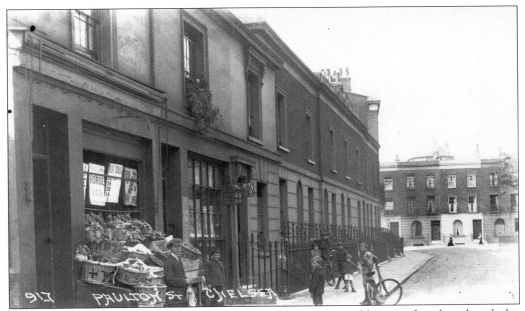

Paultons Street, *c.* 1922. The little shop here sold fruit, vegetables, wood and coal and also provided a removals service; their horse van was also available for hire. One hopes that the same vehicle was not used to carry all the produce, coal and household effects. The shop has been demolished and a small terrace of three-storey houses has been built that is compatible with the older properties in neighbouring Paultons Square.

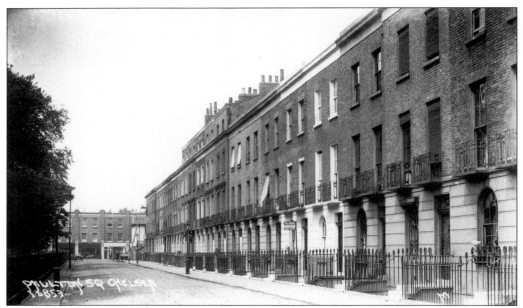

Paultons Square, *c.* 1925. The above view is of the east side and below of the west side. On the death of Sir Hans Sloane in 1753 and the division of Chelsea Manor between the two daughters, half went to Sarah Sloane, wife of George Stanley of Paultons in Hampshire. The houses were built in 1840 and the group is considered a good example of a uniform square laid out in late Georgian style. On one day, 9 May 1870, Chelsea witnessed two murders by one man. Walter Miller, a plasterer from Fulham, murdered the Revd Elias Huelin at 24 Wellington Square (the clergyman owned several properties in Chelsea), robbing the victim of cash and valuables and then proceeded to the clergyman's main house at no. 15 Paultons Square where he also murdered the housekeeper, Ann Boss. After spending several days drinking in the company of a woman, he was caught, tried and hanged.

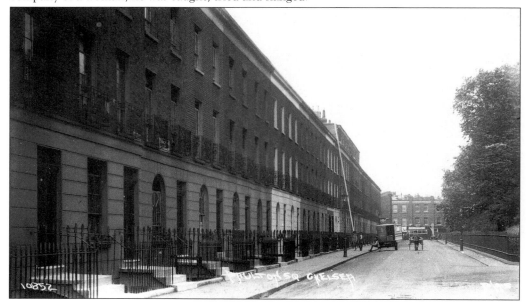

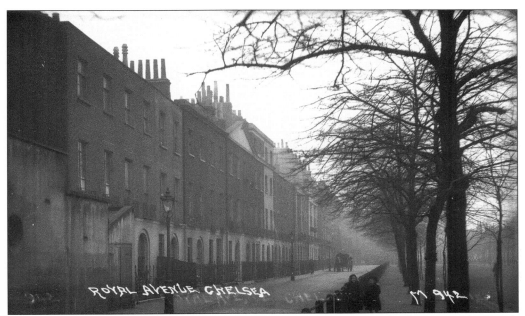

Royal Avenue, *c.* 1918. The Avenue was originally intended as part of a drive from the King's Road, which was to run through Burton's Court southwards to the Royal Hospital, but was never completed. The Royal Hospital provides a magnificent backdrop at the southern end of the Avenue. This was one of the proposed sites for the erection of the war memorial, which is now in Sloane Square.

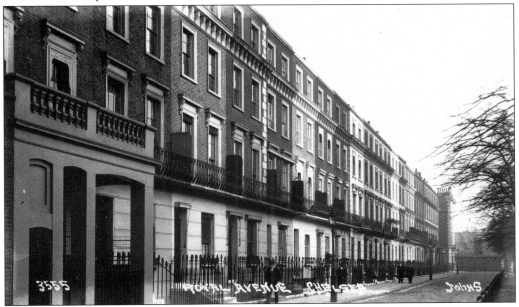

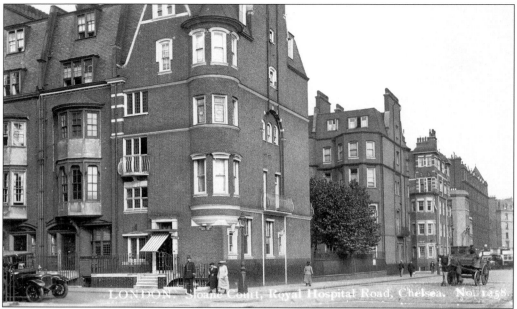

Royal Hospital Road with Sloane Court West on the immediate left, *c.* 1925. The grounds of the Royal Hospital are on the right. On the right beyond the horse and cart is Pimlico Road and Sloane Street. A public house, named the Royal Hospital Inn, stood on the left-hand corner from the mid-eighteenth century until demolition in the late nineteenth century to make way for construction of the block of apartments named Sloane Court West.

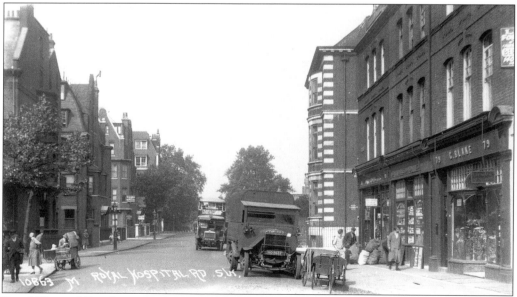

Royal Hospital Road, *c.* 1928. Tite Street is to the right, at the end of the shopping parade and also to the left of the small hand pushed cart. The three-storey block beyond Tite Street is the Victoria Hospital for Children, now demolished (see p. 74). Tite Street is named after Sir William Tite MP (1798-1873). An earlier name was Calthorpe Place but this was altered about 1881; the name Tite Street was approved in 1875.

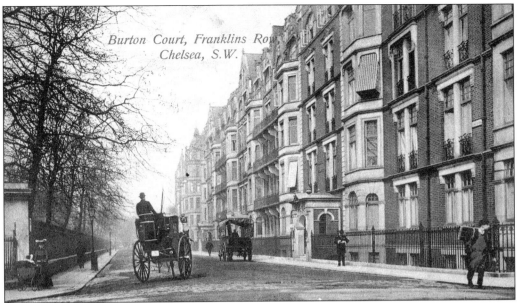

Burton Court, Franklin's Row, off Royal Hospital Road, *c.* 1905. The residents of this late Victorian apartment block have the pleasure of overlooking Burton's Court, a pleasant fenced green originally purchased in 1687 to provide an extension to Royal Avenue but now used for sporting activities. Thomas Franklin, a farmer turned builder, built the first four properties and a public house here in 1699 and he also built the roadway around three sides of Burton's Court.

Ormonde Gate, *c.* 1914. The name comes from Ormonde House, which stood nearby. The house, dating from 1691, was home to Mary, the wife of James, 2nd Duke of Ormonde, who lived there from 1730 to 1733. From 1777 the house was in use as a Naval Academy, even having in the back garden a model ship named the *Cumberland* on which the young ratings could climb the riggings. The house was demolished about 1890.

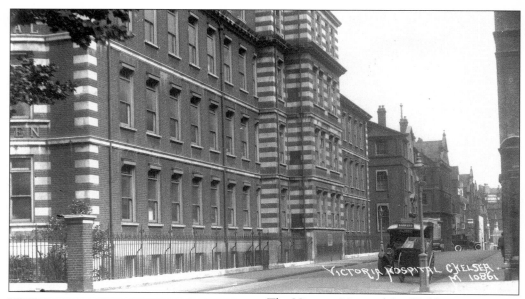

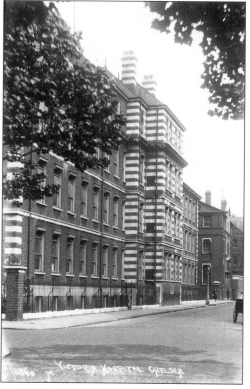

The Victoria Hospital for Children, Tite Street, *c.* 1928. The hospital was opened in 1866 in a converted house, originally built at the end of the seventeenth century, called Gough House. The hospital was enlarged in the 1890s with beds for 103 patients. The hospital was demolished in the 1960s and services were transferred to St George's Hospital at Tooting. The site was used for the building of St Wilfred's Residential Home for the elderly.

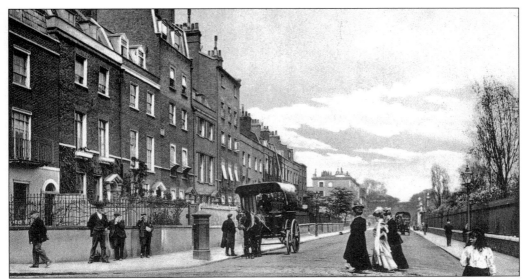

St Leonard's Terrace, *c*. 1905. This row of late eighteenth- and early nineteenth-century houses faces the green of Burton's Court. The Irish novelist, actor and theatre manager Abraham Stoker (1847-1912) lived at no. 18 from 1896 to 1906 and in 1897 brought us the immortal legend of the vampire Count Dracula. The comedienne and actress Joyce Grenfell had several Chelsea homes; amongst them were nos 28 and 21 St Leonard's Terrace. The actor Laurence Olivier also lived in the terrace. The Victorian pillar-box on the corner of Smith Street still survives. The road name was approved in 1845 and is probably after the builder, John Tombs who was a native of Gloucester: the village of Upton St Leonards is three miles south-east of the city.

St Loo Court, St Loo Avenue, off Flood Street, *c*. 1928. Sir William St Loo, Captain of the Guards to Queen Elizabeth I, was the third husband of Elizabeth of Hardwick. Her fourth husband was the Earl of Shrewsbury, who owned Shrewsbury House, later renamed Alston House which stood near to Oakley Street. The house was built in 1530 and gradually demolished after the year 1813 when it was derelict.

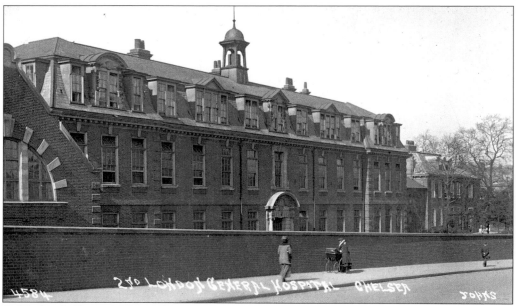

St Mark's College, *c.* 1914. Above is the King's Road frontage and below is the view from the Fulham Road. The college was founded in 1840 by the National Society as a teacher training college for male students. The society paid £9,000 for Stanley House (or sometimes called Stanley Grove), dating from the 1690s, the former home of such worthies as William Hamilton, who had plaster casts of the Parthenon marbles at the house. Hamilton was the British envoy at the Court of Naples. Stanley House was used as the Principal's office and the college buildings were erected to the designs of Edward Blore. During the First World War the college was converted for use to help cope with the tens of thousands of wounded troops evacuated from the battlefields of France and Belgium and was designated as the Second London General Hospital.

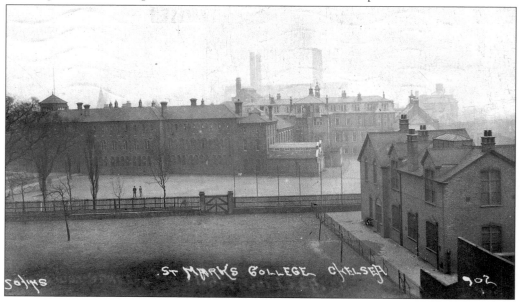

76

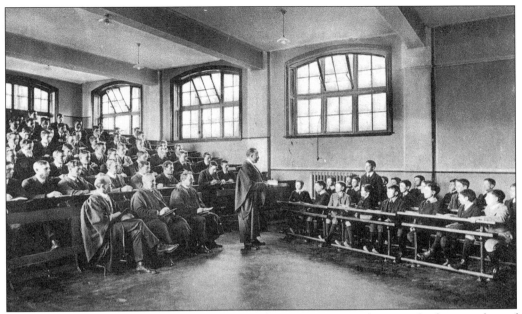

St Mark's College, *c*. 1914. A form-master is demonstrating teaching methods on a class of young pupils, to the teacher trainees sitting on the left. The college was merged in 1923 with St John's College, Battersea, also founded in 1840 and previously a great rival at rugby, football and other sports. St Mark's moved to Plymouth, Devon in the 1970s and the grounds were bought out as the Chelsea campus of King's College, London. The site occupies approximately nine acres.

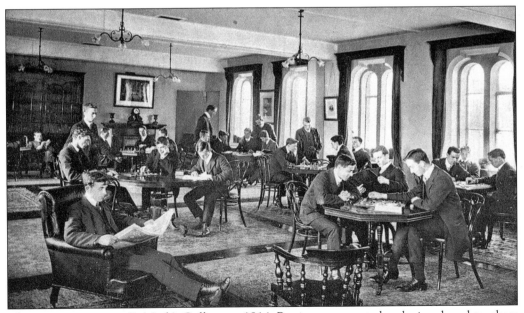

The common room at St Mark's College, *c*. 1914. Pastimes appear to be playing draughts, chess and reading all the world's news.

Carlyle School, Hortensia Road, *c. 1928*. The school was built in 1908 by the LCC, as their first purpose-built school for the secondary education of girls. The school was provided with a gymnasium, dining room, kitchen and cookery room on the ground floor and on other floors were two art rooms, three laboratories, a museum and music rooms. Two tennis courts were also provided. The Carlyle School for girls was brought here in 1914 from the Chelsea Polytechnic, Manresa Road, where secondary education for girls was previously provided. The building is now the Hortensia Centre, which is part of the Kensington and Chelsea College.

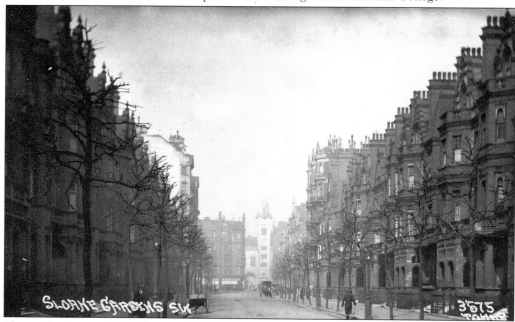

Sloane Gardens, *c. 1914*. The mansions here were built in the 1880s and 1890s on Cadogan estate land, replacing many small, overcrowded and run-down houses. An innovation of the Cadogan Estate management in the 1980s was to instigate external stone and brickwork cleaning of their properties by new leaseholders, which immediately improved the buildings. In the background, beyond Sloane Square, can be seen the First Church of Christ, Scientist in Sloane Terrace.

Sloane Court East, *c*. 1914. The mansions, set off Royal Hospital Road, were completed about 1890 to designs of the Cadogan Estate architects, Messrs Rolfe and Mathews. *The Builder* magazine, reporting in 1889, stated that the narrow streets of squalid houses in Chelsea had been transformed into wide avenues of mansions.

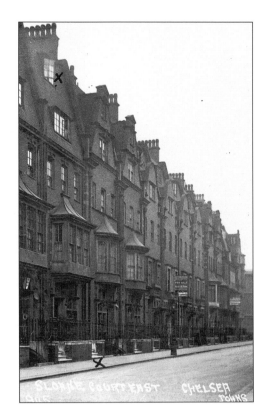

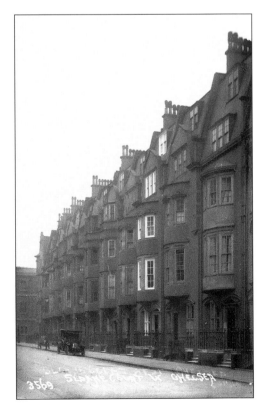

Sloane Court West, *c*. 1914.

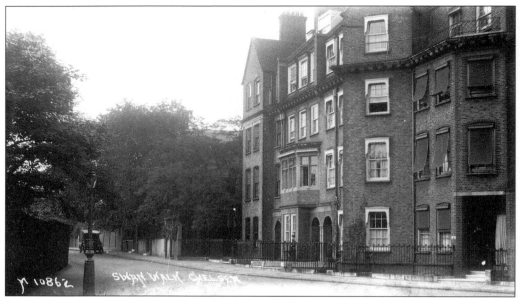

Swan Walk from the Embankment, c. 1928. The construction of the embankment led to the demolition of The Old Swan Tavern which stood on the riverside nearby. To the left is the physic garden, which dates from 1673 when the Apothecaries' Company took a lease on 3½acres of land at Chelsea at £5 per annum. Sir Hans Sloane made this sum perpetual in 1722. The Apothecaries' Company set up a marble statue in the garden to Sir Hans Sloane in 1723. The garden was originally only for herb cultivation but with Sir Hans Sloane's involvement it soon became a centre for collection of specimens associated with botanical medicine.

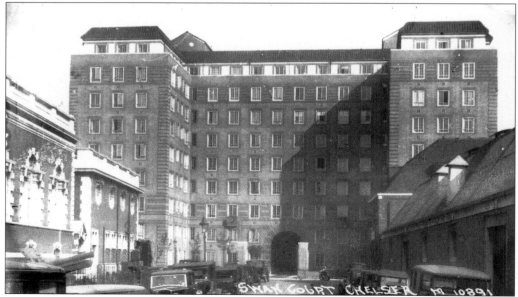

Swan Court from Chelsea Manor Gardens, c. 1933. On the left is the municipal swimming baths; today it is the Chelsea Sports Centre comprising a sports hall, fitness room, dance studio and a swimming pool. The block on the right, a former garage, has been demolished and Chelsea Towers, an office block, has been erected on the site.

The Manor Street entrance to Swan Court, *c*. 1933. In the background is the Wesleyan Methodist church, damaged in the Second World War. The site of the Wolseley service station was sold in around 1927 by Allsop and Co. to the first Lord Melchett, Minister of Health in the early 1920s, for development. The southern part of the site was given for the Melchett Welfare Centre and on the rest of the site was erected Swan Court. The architects were Messrs Buckland and Hayward of Birmingham and the complex was completed in 1931. The developers, Manor Developments Ltd, sold the block to Swan Estates Ltd who in 1943 were incorporated as part of Property Holding & Investment Trust Ltd, the present landlords. An early incident in the Blitz was at about 6 p.m. on 9 September 1940 when a bomb fell on the north-east corner of the block. It caused much damage but due to effective evacuation and the absence of residents serving in the forces, there were no injuries. The party wall to the adjoining property still has splinter fragments from the bomb embedded in the mortar rendering.

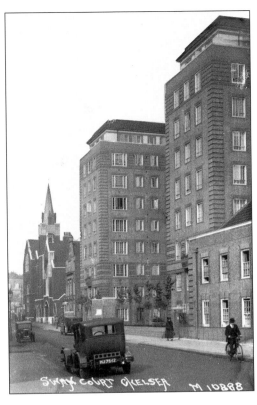

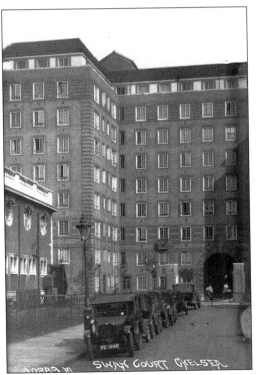

Swan Court, Chelsea Manor Gardens entrance, *c*. 1933. When the block was completed in 1931 it was considered the largest block of flats to be built and let at inclusive rent, except for any excess local rates. Specially designed furniture was available to be installed in any flat. The block was built with 144 self-contained flats but some of these have since been amalgamated. In March 1932 a memorial to Lord Melchett was unveiled inside the welfare centre. Part of the inscription reads 'And he who gives a child a treat, makes joy bells ring in heaven's street. And he who gives a child a home, builds palaces in kingdom come'.

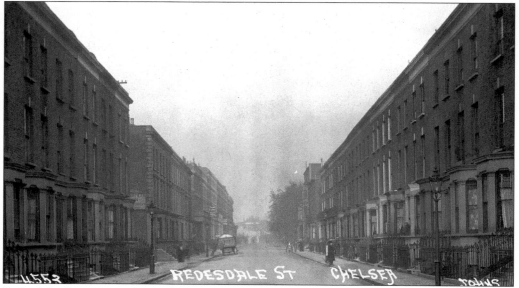

Redesdale Street, c. 1914. The view is facing eastwards towards Tedworth Square with Shawfield Street on the left. Lord Redesdale lived in Lindsey House, on Cheyne Walk. The road name was approved in 1871.

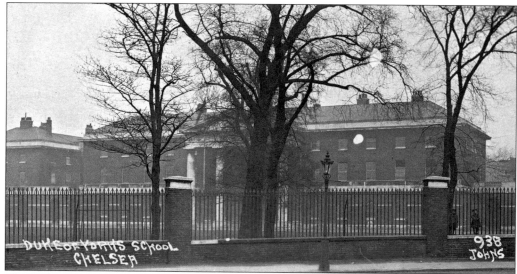

The Duke of York's School, King's Road, c. 1914. The foundation stone was laid on 19 June 1801 for the 'Royal Military Asylum for the Children of Soldiers of the Army'. The patron was HRH Frederick, Duke of York, Commander in Chief of the Army. The major buildings were erected in the period 1801-1803 to the designs of John Sanders. One thousand orphans were schooled in the three Rs to military discipline. The 300 girls were moved to another establishment at Southampton in 1823 and eventually the boys were removed to Dover in 1909. The buildings were taken over in 1912 as the Duke of York's headquarters for all London Territorial Army Reserves. Since 1984 a refurbishment and stone-cleaning programme has been carried out with splendid results that has brought out the original colour of the brick and stonework.

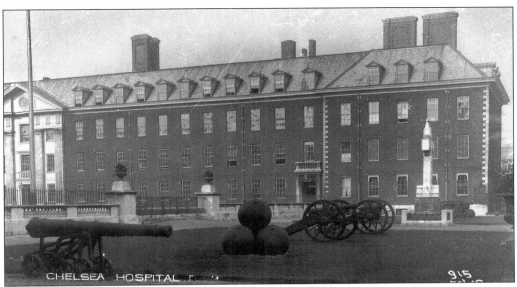

Chelsea Hospital, *c.* 1905. The hospital was begun when Charles II laid the foundation stone on 16 February 1682 and was completed in 1692. Sir Christopher Wren had designed the building to house 400 sick or infirm soldiers, ward captains and governors within just over 50 acres of ground. The great hall, measuring 110ft by 30ft, was originally used as a dining room but is now used by the pensioners as a recreation area. The body of the Duke of Wellington lay in state here in 1852. The pensioners wear their red frock coats during the summer months and navy blue in winter. The famous tricorn hats are only worn on ceremonial occasions, such as on 29 May each year – Founders Day, the birthday of King Charles II. The occasion is also called Oak Apple Day, in celebration of his escape from Parliamentarians after the battle of Worcester, when he hid in an oak tree for a day and a night. Ranelagh Gardens, alongside Chelsea Bridge Road, were later added to the hospital grounds, which total 66 acres.

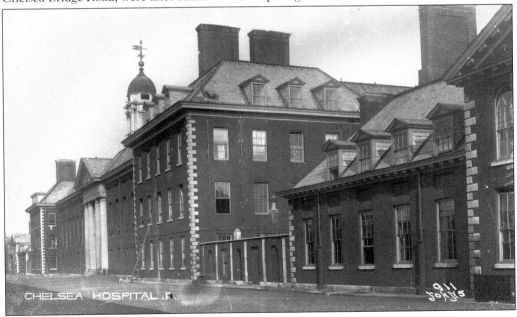

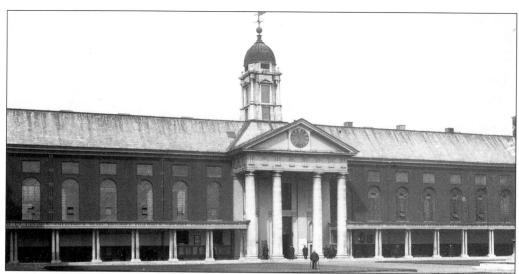

The entrance to the main hall of Chelsea Hospital, *c.* 1912. The forecourt, known as the Figure Court, is graced by a bronze statue of King Charles II by Grinling Gibbons; this was presented to the hospital by Tobias Rastat, a page at court. Within the Doric colonnade are memorials to past governors, officers and also to the twenty-three pensioners, staff and residents killed in the air raids of both world wars. The south grounds have been used each year since May 1912 by the Royal Horticultural Society for its annual flower show. The show expanded to take up Ranelagh Gardens in 1922 and is now called the Chelsea Flower Show, which attracts over 200,000 visitors each year. The show was cancelled in 1917 and again from 1939 to May 1947. The great marquee covers $3\frac{1}{2}$ acres and is considered to be one of the largest in the world.

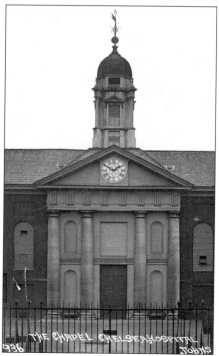

The Chapel, Chelsea Hospital, *c.* 1912. The chapel was consecrated on 13 October 1691 by Dr Compton, Bishop of London. The chapel has the same dimensions as the great hall, i.e. 100ft by 30ft, and houses captured standards from the many wars of the past 300 years.

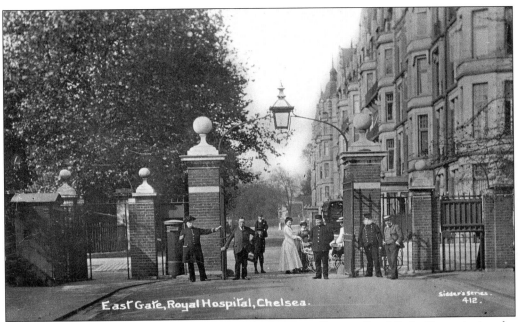

The East Gate, Chelsea Hospital, *c.* 1908. Burton Court, Franklin's Row, is in the background.

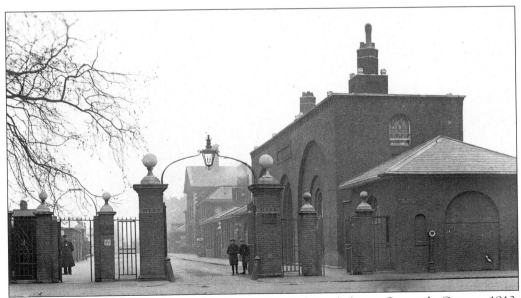

The West Gate of Chelsea Hospital in Royal Hospital Road, facing Ormonde Gate, *c.* 1912. Some cleaning and repairs have taken place but the scene is identical today.

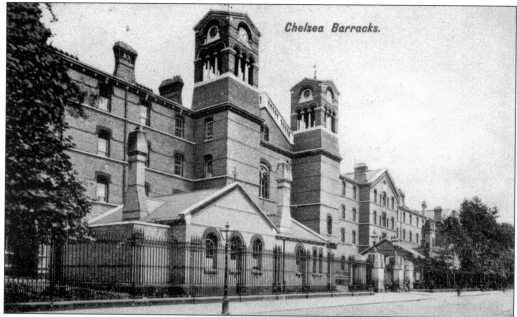

Chelsea Barracks.

Chelsea Barracks, Chelsea Bridge Road: *c.* 1905 (above) and *c.* 1910 (below). Although called Chelsea barracks, they are in fact in Westminster, as the parish boundary was altered in 1899. The barracks were opened in 1862 for the Guards Regiment and had a frontage of 1,000ft along Chelsea Bridge Road. Some people passing by on the upper decks of buses were startled to see the number of 'black cats' asleep on the window ledges; they were in reality the guards' Busby fur hats left out to freshen up! The Victorian barracks were demolished in the late 1950s and replaced in 1960-1962 with blocks set well back from the roadway. The designers of the new barracks were Tripe and Wakeham.

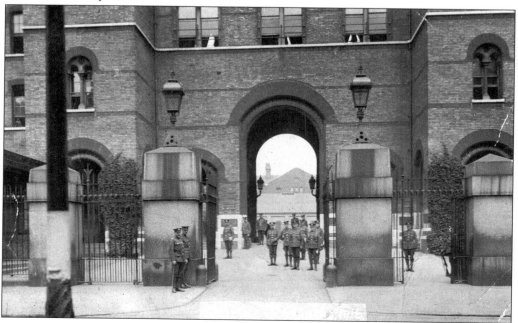

Four
Streets North of King's Road

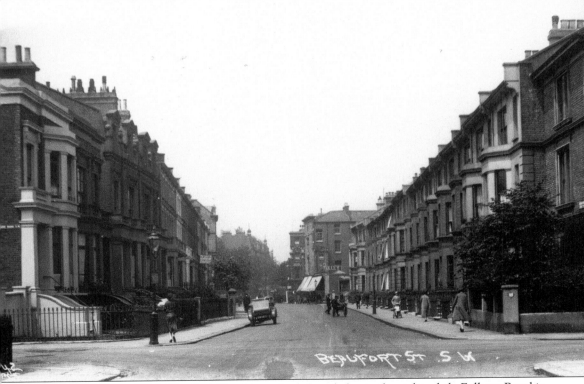

Beaufort Street, c. 1928. Elm Park Road is to the left and also to the right while Fulham Road is in the far distance. The street is named after Henry Somerset, 1st Duke of Beaufort (1629-1709). Beaufort House, where the Duke lived from 1682 to 1699, stood south of the King's Road. This had been Sir Thomas More's house but was demolished by Sir Hans Sloane in 1740.

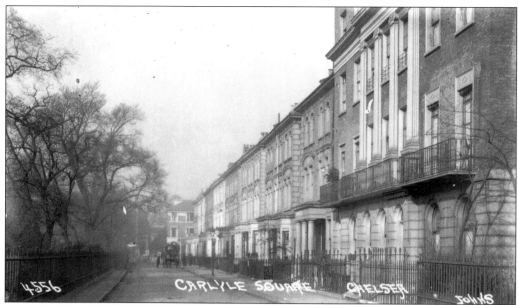

Carlyle Square, c. 1914. The square was originally named Oakley Square but was changed in 1872 to Carlyle Square, even while the great man was still living. Lewis Casson and Sybil Thorndike, both famous in the theatre world, lived at no. 6 during the 1920s, before moving to Swan Court, Flood Street, in 1962. Sir Osbert Sitwell Bt. Ch., author and essayist, lived at no. 2 from 1916 to 1963. Perhaps one of the most notorious inhabitants of the square was the Russian Soviet spy, Kim Philby, who lived at no. 18 from 1945 until his defection and betrayal of British secrets.

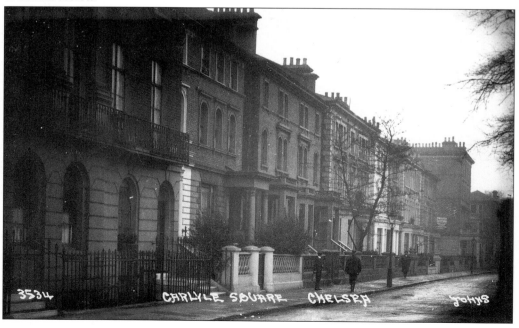

The Conservative Club, 191-193 King's Road, c. 1914. The Chelsea Conservative and Unionist Association was formed on 17 July 1885. The foundation stone was laid on 18 May 1887 and the club building opened in 1888. The club housed, on three floors, a bar, lounge, smoking room, kitchen and 'a spacious and handsome dining room' together with the Conservative Association offices. The lease of the building expired in 1935 and the Conservative Club withdrew to join with South Stanley Conservative Club further along the King's Road.

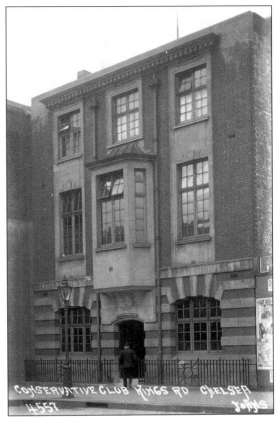

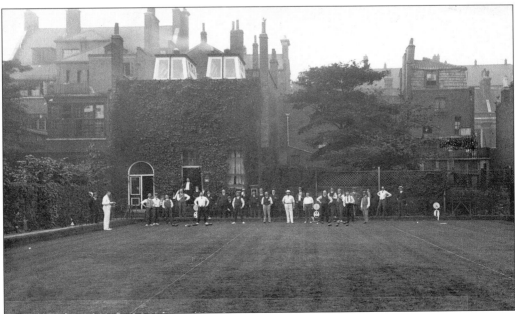

The bowling green at the rear of the Conservative Club, King's Road, c. 1910.

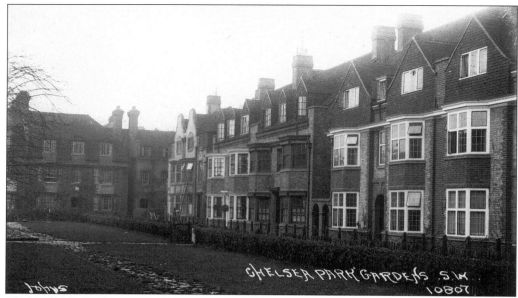

Chelsea Park Gardens, *c.* 1928. Part of Sir Thomas More's estate was called Sandhills and later named Wharton Park. In 1718 the name Chelsea Park was given when it was bought as a mulberry garden for the production of silk. Two thousand trees were planted but the scheme soon foundered. A few of the trees from this failed venture are said to remain.

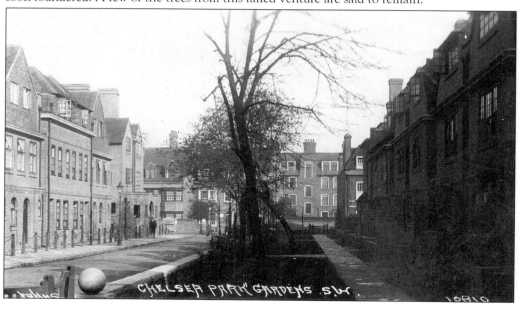

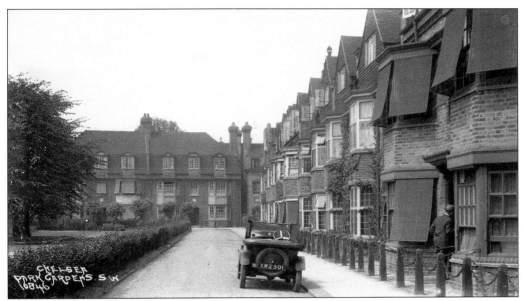

Chelsea Park Gardens, *c.* 1928. The artist Alfred Munnings (1878-1959), famous for his equestrian paintings, lived at no. 96 from 1920 to 1959. He was president of the Royal Academy from 1944. Munnings called the property Beldon House after Beldon Hall in Ireland, which is mentioned in the hunting novels of his favourite author, R.S. Surtees.

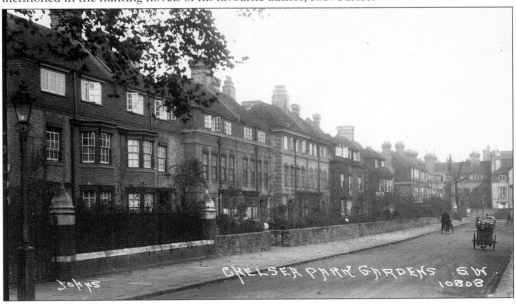

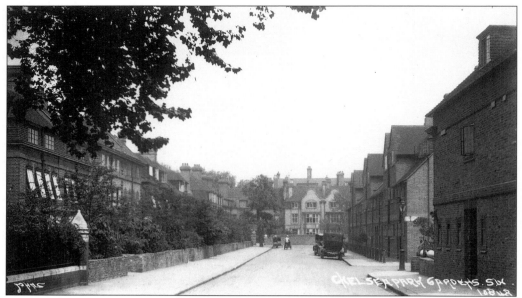

Chelsea Park Gardens, *c.* 1928. The area was originally developed in the 1830s and was first called Camera Square. The name change to Chelsea Park Gardens was approved in 1915 subject to the proviso that the central portion of the area should be laid out as a garden. The earlier properties were demolished between 1910 and 1930 to provide for the construction of the houses shown here, almost in Queen Anne style, but in a garden suburb setting. In the background in the lower view is St Andrew's church in Park Walk.

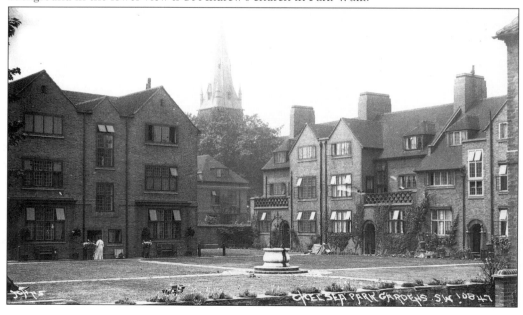

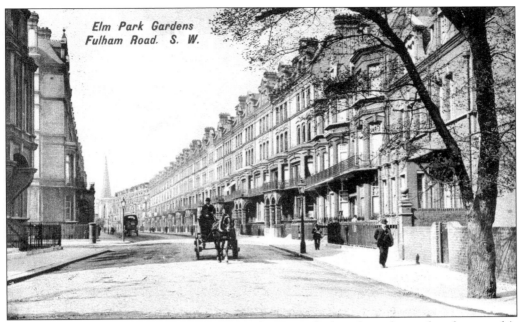

Elm Park Gardens, *c.* 1905. The terrace on the east side (on the right in the photograph), dating from the 1880s or '90s, has survived, while those on the left have been replaced with blocks of flats. In the background is St Peter's church in Cranley Gardens.

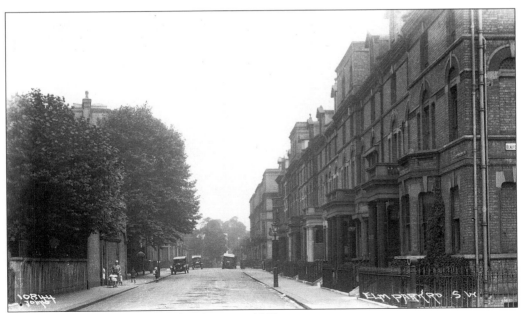

Elm Park Road, seen from Beaufort Street, *c.* 1930.

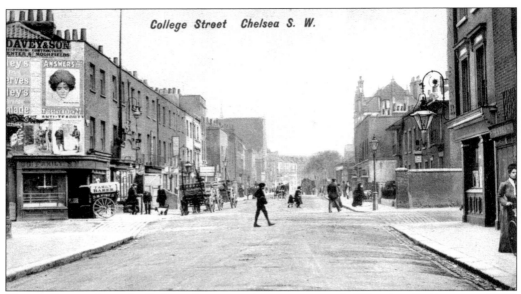

Elystan Street, formerly College Street, at the junction with Whitehead's Grove, *c.* 1905. Mr Whitehead developed much of the area. Formerly part of Chelsea Common, the land was let out for building purposes as early as 1790. The houses in this street, dating from the 1830s and 1840s, were ruthlessly demolished after 1929 when 14 acres of housing were sold off to developers. The areas of Milner Street, Draycott Avenue and Sloane Avenue soon lost their low-rise artisan's houses. The Cadogan family can trace their line back to a Welshman, Cadwgan ap Elystan, hence Elystan Street. The street renaming was approved in 1906 but did not appear until 1913.

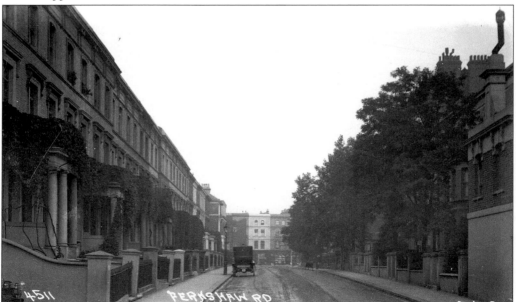

Fernshaw Road about 1914, viewed from King's Road with Fulham Road at the far end. About a third of the terrace on the left (west side) has been demolished and replaced by blocks of offices fronting onto King's Road.

94

Fernshaw Mansions, Fernshaw Road, *c.* 1914.

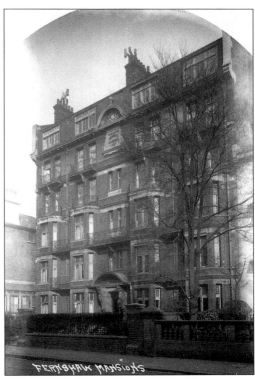

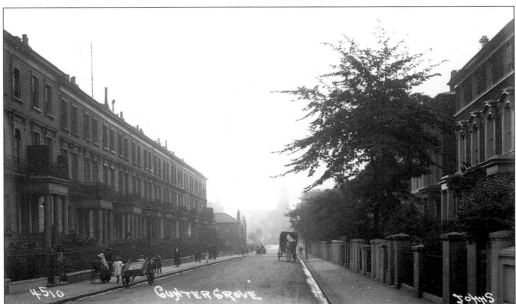

Gunter Grove, *c.* 1914. The Gunter family developed the former nursery fields between Brompton Cemetery and Stamford Bridge Football Ground, home of Chelsea Football Club, during the early part of the nineteenth century. This, narrow thoroughfare, now one-way, has a heavy traffic load from the Thames Embankment heading for Earl's Court, the Great West Road and the route to Oxford.

Hans Place, *c.* 1910. As part of the Georgian development of London, in 1779 Henry Holland began building on 90 acres of what he called Hans Town, after Sir Hans Sloane, in east Chelsea and Knightsbridge; Sloane Street and Cadogan Place were part of his development. When the leases expired in 1874 many of Holland's houses were demolished, being too large and too grand, and replaced by apartment buildings. To the left are the padlocked gardens, for private use of those residing in Hans Place. The novelist Jane Austen lived at no. 23 with her brother in 1814/15 and the poet Percy Bysshe Shelley moved into no. 41 in 1817.

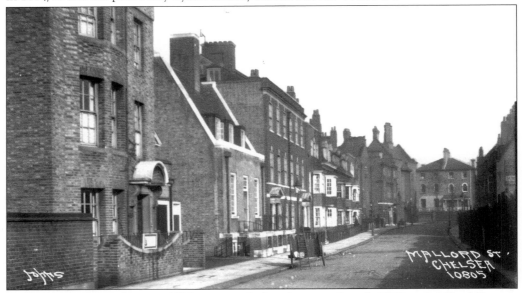

Mallord Street, seen here in 1928, is named after the artist Joseph William Mallord Turner. The story of Christopher Robin and Alice walking to Buckingham Palace to see the Changing of the Guard was conjured from the imagination of A.A. Milne (1882-1956) while he resided at 13 Mallord Street, between 1919 and 1942; he wrote the famous *Winnie the Pooh* stories during this period as well. The painter Augustus John lived at no. 28 Mallord Street in a house designed in 1914 by Robert Van Hoff. The film, stage and wireless entertainer, Gracie Fields, later bought the property.

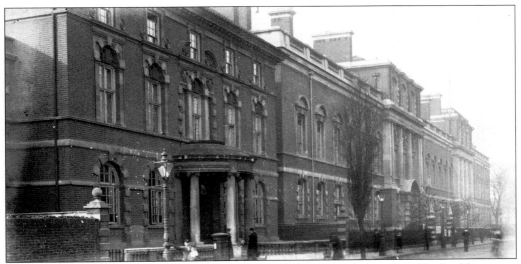

The Library and Polytechnic, Manresa Road, *c.* 1914. The foundation stone for the library was laid by Beatrix Jane, Countess of Cadogan, on 8 February 1890. The Library, built by Holloway Brothers and designed by J.M. Brydon, was opened in 1891 by the 5th Earl Cadogan KG, who had donated the site. The building was badly damaged in an air raid on 29 September 1940, when fifteen incendiary bombs set it and the neighbouring Polytechnic alight. Both were repaired and reopened after the war. The foundation stone for the Polytechnic was laid by the Prince of Wales, later Edward VII, in 1891 and the building opened in 1895 as the South Western Polytechnic Institute, the costs largely defrayed by public subscription. The Polytechnic's two main sections comprised the Chelsea School of Art and the Chelsea College of Science and Technology. It also provided secondary education for girls as the Carlyle School, and for boys as the Sloane School. Both were later relocated. The Institute was renamed the Chelsea Polytechnic in 1922. Both buildings now form part of King's College, London. The road, formerly called Trafalgar Road, is named after the town in Spain.

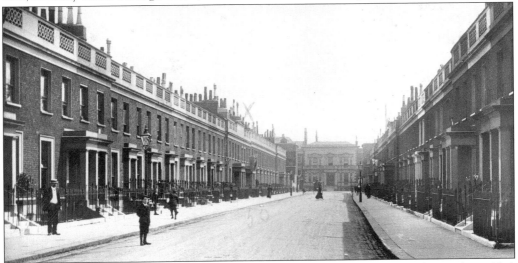

Ovington Street in 1910, viewed from Walton Street with Milner Street at the southern (far) end. The properties appear much the same today, although the parking of private cars would inhibit a modern photographer.

St Simon Zelotes' church, on the corner of Moore Street and Milner Street, *c.* 1914. The church, opened in 1859, was designed by Joseph Peacock.

St Andrew's church, on the corner of Park Road and Park Walk, *c.* 1914. The church, with accommodation for 700 people, is recognized as a good example of Decorated Gothic; it was designed by the sons of Sir Arthur Blomfield RA and consecrated in 1913 by the Bishop of London. The costs were borne by a generous parishioner, Mr Charles A. Bannister. The site was formerly occupied by Park Chapel, built in 1718 with funds provided by Sir Richard Manningham. The chapel, by then called Emmanuel church, was demolished for construction of St Andrew's.

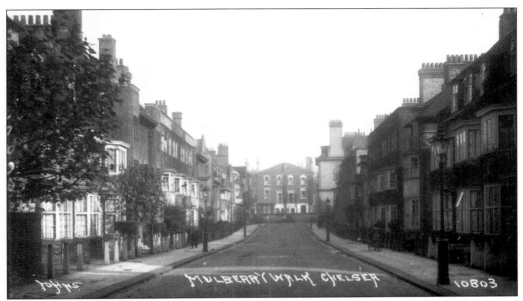

Mulberry Walk, *c.* 1930. On the Chelsea Park Estate in 1718 there was an experimental plantation of mulberry trees, hence the name.

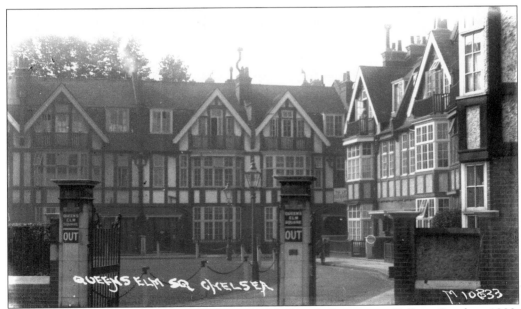

Queen's Elm Square, at the northern part of Old Church Street near Fulham Road, *c.* 1933. The crossroads here is known as Queen's Elm, after a story about Queen Elizabeth I who, while visiting Lord Burleigh, had to shelter from a shower of rain under an elm tree and afterwards proclaimed 'Let this henceforward be called the Queen's Tree'. Consequently the pub on this corner was called the Queen's Tree and later renamed the Queen's Elm. (See also p. 111)

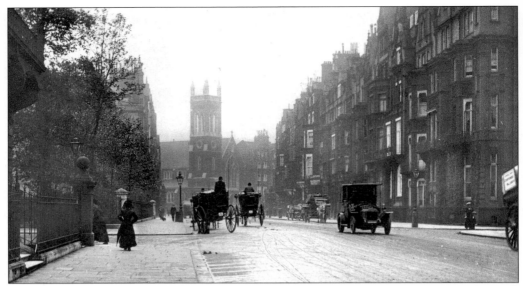

Pont Street, *c.* 1910. At no. 57 lived Sir George Alexander (1858-1918), an actor who took over as manager of St James's Theatre in 1891 where he staged plays by Oscar Wilde, Arthur Wing, Pinero and Sutro. Mrs Patrick Campbell lived at no. 64 from 1928 to 1940; she appeared at St James's Theatre in 1893, introduced by Sir George Alexander. Lily Langtry (1852-1929) lived for a while at no. 18. The author Rafael Sabatini (1875-1950), who wrote, amongst other titles, *Captain Blood*, lived at no. 22 during the 1920s and '30s.

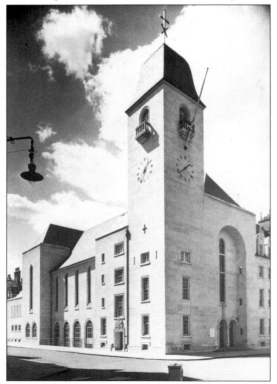

The original St Columba's church was built in 1883/84 to the designs of the architect John Macvicar Anderson for the Scots Presbyterians. The tower of red brick and Doulton stonework, 113ft tall, is seen in the upper view. The church was destroyed by bombs in May 1941. Queen Elizabeth, the present Queen Mother, laid the foundation stone for the present church, on 4 July 1950. The building was designed by Sir Edward Maufe and constructed of Portland Stone at a cost of £284,000 and reopened in 1954.

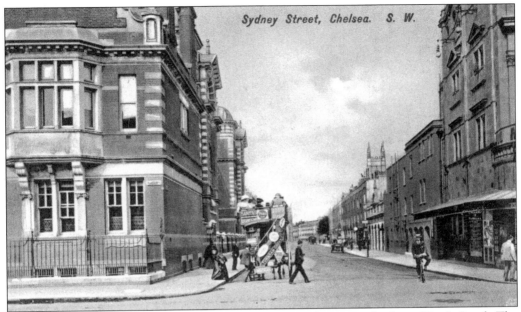

Sidney Street, both views c. 1905. The upper view is facing north, from King's Road. The Chelsea Palace theatre is on the right and the Board of Guardians' Office is on the left. The lower view is facing south from Fulham Road. This end of the road was known as Robert Street in the early 1830s and by March 1839 was called Upper Robert Street. By October 1847 it had become Sydney Street. The Rt. Hon. Thomas Townsend, later Viscount Sydney, was the Paymaster General of the Royal Hospital in 1767 and John Thomas, Viscount Sydney, was a trustee of the Smith charity, during their developments of the 1860s and '70s. The northern end of the street, between Fulham Road and Cale Street, was part of Robert Gunter's developments of 1845-1847. They were designed in late Georgian style by W.W. Pocock and George Godwin.

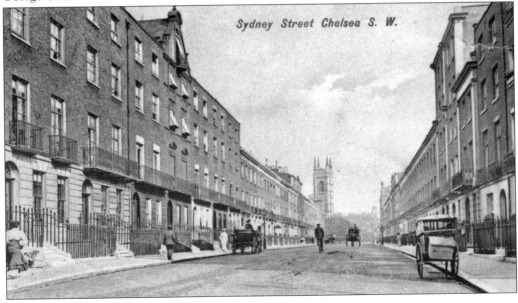

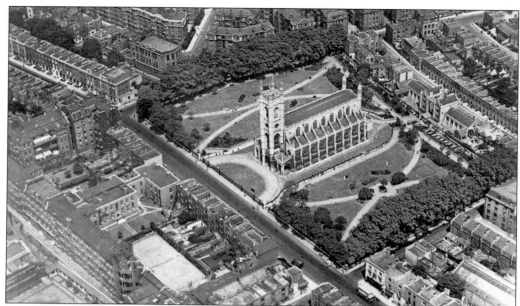

Two views of St Luke's parish church in Sydney Street. The aerial view dates from around 1925; the ground view is a little earlier. Built in 1824 as a new parish church as the old church by the riverside, also St Luke's, was no longer able to house the increasing number of parishioners. James Savage designed the new church in the early Gothic Revival style. The Duke of Wellington laid the foundation stone on 12 October 1820 and the church, costing slightly over £40,000, was consecrated on 18 October 1824 by the Bishop of London. Charles Dickens married Catherine Hogarth here on 2 April 1836. To the left is St Luke's Hospital, originally the workhouse infirmary, which closed in the 1970s.

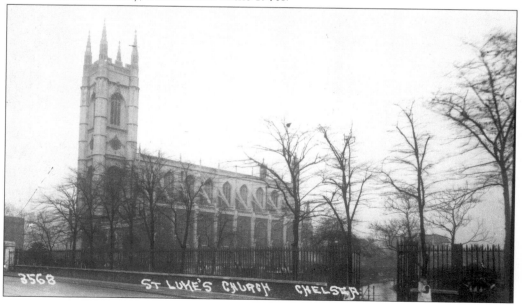

Two views of The Vale, 1926. The road had seen a number of famous residents, including the ceramist and potter, William de Morgan, who in 1909 gave a party to see the end of the old buildings in the Vale which was to be redeveloped the following year. The painter Whistler lived at no. 2 from 1886 to 1890. Residents of the Vale in 1924 attempted to have the name altered to Vale Avenue but were refused, although the sought-after change is recorded in the caption to these photographs.

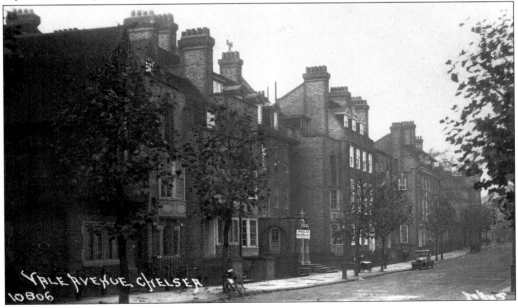

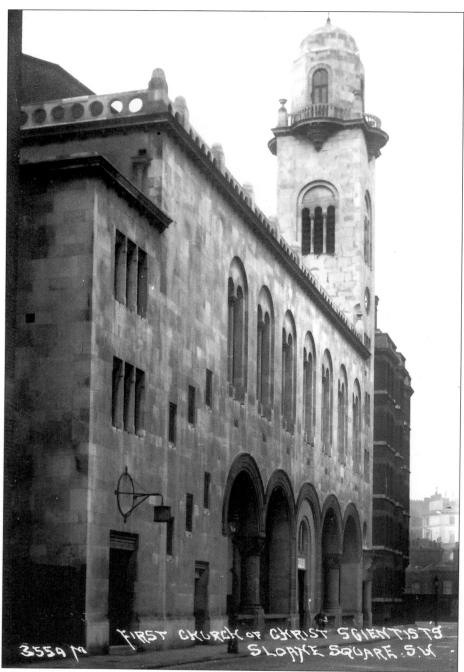

First Church of Christ Scientist, Sloane Terrace, off Sloane Street, *c.* 1914. The church was designed by R. Chisholm and erected between 1904 and 1909. The Byzantine-style church, seating 1,320, is of Ashlar facing with a five-bay granite arcade at ground level. The capped, domed campanile on the south-east corner is prominent in the photograph. The foundation stone is marked: 'This corner stone of granite from Concord, New Hampshire was laid on November 29th 1904 and the church was dedicated on June 13th 1909'.

Five
Fulham Road,
North Chelsea
and Brompton

Fulham Road, c. 1928. The Thornycroft lorry has just passed Edith Grove, opposite Redcliffe Gardens. The shops and flats on the left, nos 270 to 296, built by Corbett and McClymont in the 1860s, were designed by Henry and Charles Godwin and survive intact. But, on the right, next to Gunter Grove, only three of the private houses remain, no. 423 being called The Cricket House. The nine properties beyond Edith Grove, have survived relatively unaltered.

Fulham Road, at the corner of Beaufort Street, *c.* 1928. The parade of shops in the 1920s included John Tulley's clothing and fabric store on the nearest corner and the parade still provides a variety of retail outlets.

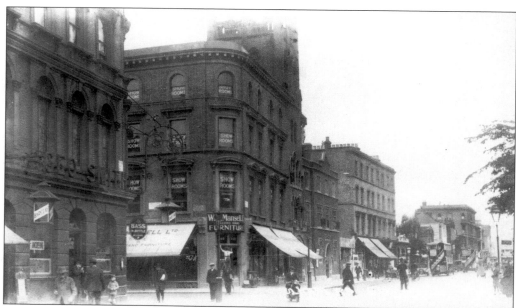

Fulham Road, *c.* 1928. On the left corner is the Redcliffe Arms public house, dating from the 1865 Gunter Estate development. The pub has been renamed the Fulham Tup, but attached is the Redcliffe Hotel. The four-storey building at no. 266, on the next corner, dates from 1868. Although a second-hand furniture store in this photograph, it is now London House, housing offices. Two doors further along at no. 264 is St Mary's Priory and Servite Catholic church, designed by J.A. Hansom and Son. It was begun in 1880 and the tower was completed in 1895.

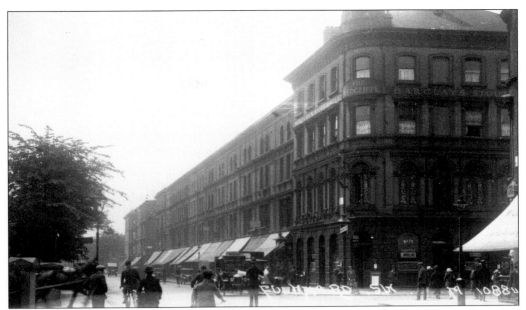

Fulham Road about 1928, with Redcliffe Gardens on the right and the Redcliffe Arms public house towering above the neighbouring shops. A policeman on point duty has raised his arms to halt traffic in Fulham Road to allow a horse and cart through from Edith Grove on the left.

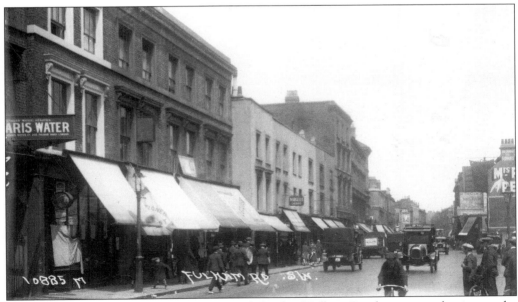

A small band of musicians marches along the left side of Fulham Road, opposite what is now the Chelsea and Westminster Hospital, c. 1920. The unemployed and ex-servicemen would form these small groups of players to gather money from the public. The parade of shop and flats on the left has been partly demolished and rebuilt. The building and passageway on the immediate left has been totally rebuilt and is now called Farrier Walk, a private Mews development.

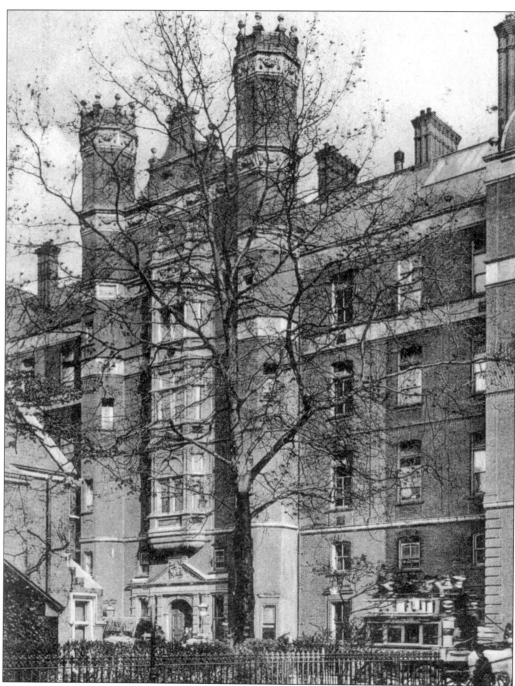

The extension to the Brompton Hospital on the south side of Fulham Road, c. 1905. The foundation stone was laid by the Prince of Wales in 1879 and the hospital, designed by T.H. Wyatt, was opened in 1882. A subway was constructed under the Fulham Road, connecting the new site with the parent hospital opposite. The building now forms part of the Royal Brompton & Harefield Hospital, specializing in cardiology.

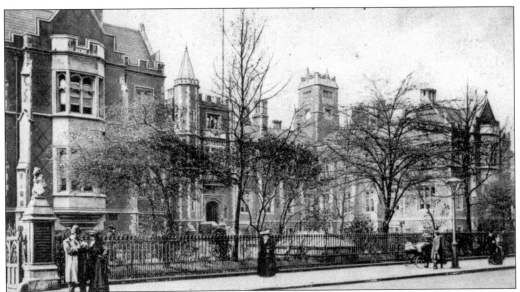

The Consumption (tuberculosis) Hospital, Fulham Road, *c.* 1905. Foulis Street is to the left. The hospital was designed in ornate Elizabethan style by Frederick Francis and cost £10,000 to construct. The foundation stone was laid in 1844 by HRH Albert, the Prince Consort and the hospital first admitted patients in 1846. The hospital buildings, after being declared redundant, have recently undergone a transformation, including brickwork and stone cleaning and many other improvements for conversion into luxury flats, to be called the Bromptons.

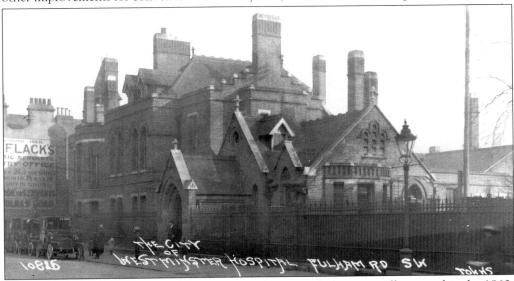

The City of Westminster Hospital, Fulham Road, *c.* 1920. It was originally erected in the 1860s by the parish of St George, Hanover Square, as a hospital for the poor of Westminster. Renamed St Stephen's Hospital in the 1920s, the old buildings, seen here, were largely replaced in the 1960s. It underwent another name change in 1993 to the Chelsea and Westminster Hospital and has become an advanced medical centre. The St Stephen's Centre, a separate building next to the hospital, houses the Kobler Clinic, a leading national and international centre for treatment and care of HIV and AIDS sufferers.

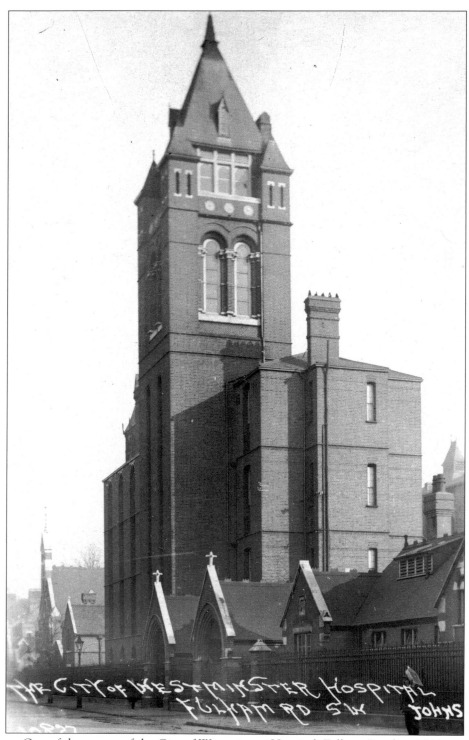

One of the towers of the City of Westminster Hospital, Fulham Road, *c.* 1914.

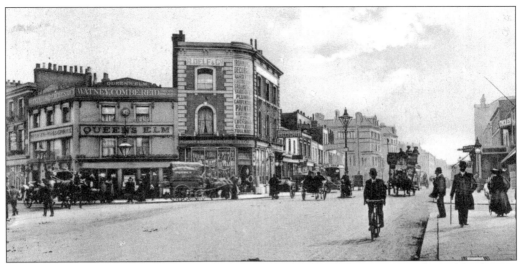

Fulham Road, *c.* 1905. Old Church Street is to the left of the Queen's Elm public house, no. 241. This Victorian pub was demolished and rebuilt in the 1930s together with the adjoining parade of shops. The pub has been without a publican for some years and now lies empty and strewn with rubbish.

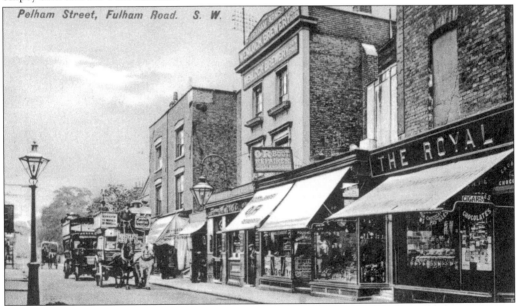

Pelham Street, *c.* 1905. This is just north of Fulham Road, actually part of South Kensington in the SW7 district. On the right is the Pelham Arms public house, now demolished, as was the rest of the street during the 1930s. The street was developed by the Smith Charity Trustees from 1833 onwards. Pelham was a trustee of this charity, which was originally founded on the death of Henry Smith in 1628. It was set up to assist 'the relief of poor prisoners, hurt and maimed soldiers, poor maids' marriages, setting of poor apprentices, amending highways and to redeem poor captives and prisoners from the Turkish tyranny'. Another sum was allocated for the use and relief of his poorest kindred. The charity now provides for medical research, hospitals and assisting the disabled.

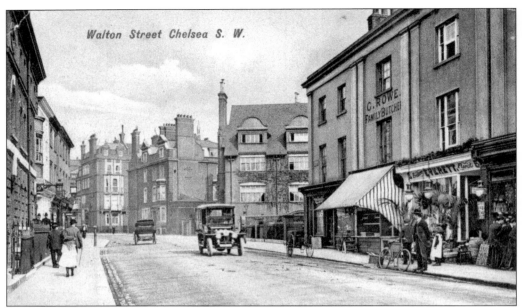

Walton Street, *c.* 1905. The author P.G. Wodehouse (1881-1975) lived at no. 16 Walton Street from 1918 to 1920; before this he had lodgings in the King's Road. To the left of the furthest motor car is Walton Street police station and opposite is the Brompton magistrates' court.

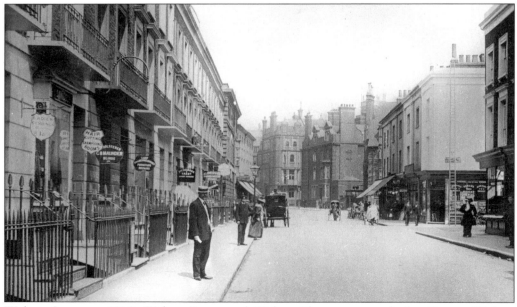

Walton Street, *c.* 1910. Walton Street and Walton Place are named after George Walton Onslow, a trustee of the Smith Charity, which was responsible for much of the development in this area during the 1840s. The terrace on the left has been demolished and smaller houses erected that blend in with the southern end of the street.

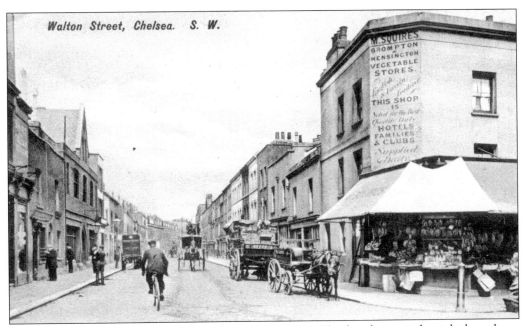

Walton Street at the corner of Draycott Avenue, *c.* 1905. The few shops on the right have been demolished and rebuilt but otherwise the view is unchanged.

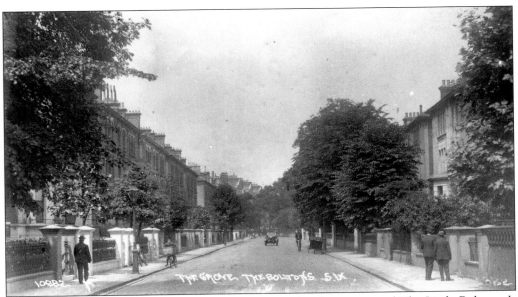

Originally called The Grove, The Boltons, this street has been renamed The Little Boltons. It is seen here in around 1926. The name is thought to come from the previous owners of the land, the Boulton family. Building started here in the late 1850s.

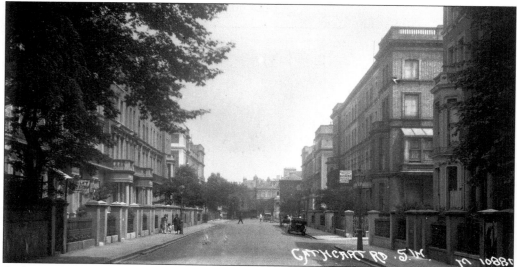

Cathcart Road, *c.* 1930. The road cuts across several others – Finborough Road, Redcliffe Gardens, Hollywood Road and ends at Redcliffe Road. The layout of the roads on the Redcliffe Estate was submitted in 1864 by the builders, William Corbett and Alexander McClymont, to the Metropolitan Board of Works who approved them almost immediately. The building work commenced in Cathcart Road with nos 26 to 32 (even) and 9 to 15 (odd) in 1864. Cathcart House, at the junction with Redcliffe Road, was newly built in 1867 when Alexander McClymont moved here.

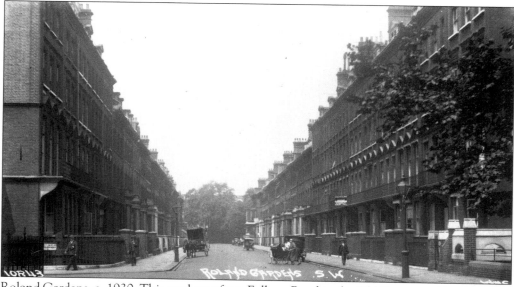

Roland Gardens, *c.* 1930. This road runs from Fulham Road to the Old Brompton Road. Roland Gardens was laid out for building in 1870 on the former grounds of Eagle Lodge Estate. The developer was Charles Aldin and after his death in 1871 the work was continued by his sons, Charles and William. The development was half completed by 1874, consisting of Nos 2-24 and 1-23. Fourteen of the houses were occupied by 1873 and further development was then delayed until eventually finished around 1893. The site later occupied by Nos 40-46 and 37-49 was a roller-skating rink from 1876 to 1881.

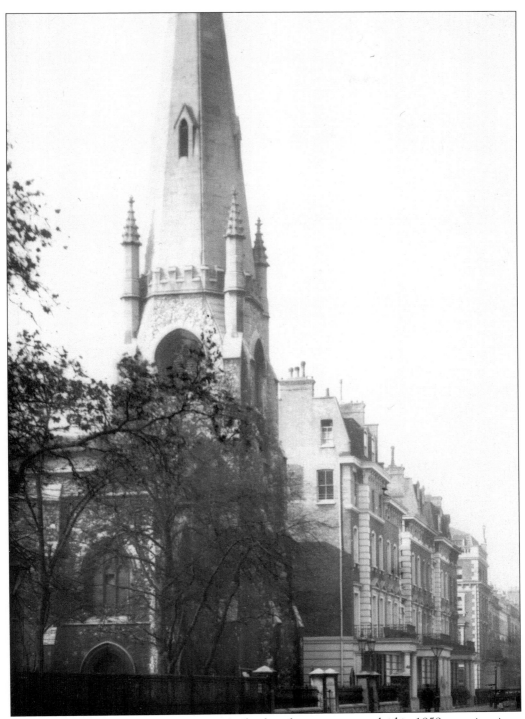

St Paul's church, Onslow Square, *c. 1925*. The foundation stone was laid in 1859 on a site given by the Smith Charity; the architect was James Edmeston. The church was consecrated on Christmas Eve 1860.

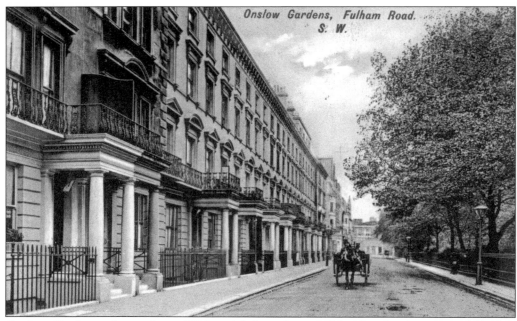

Onslow Gardens, above about 1905 and below about 1925. The development of Onslow Gardens was initiated in 1861 by Charles J. Freake, developer and benefactor of much of the Smith Charity's South Kensington estate. Development continued into the 1880s. William Joyce, the infamous Lord Haw-Haw, lived at no. 83 Onslow Gardens in 1938.

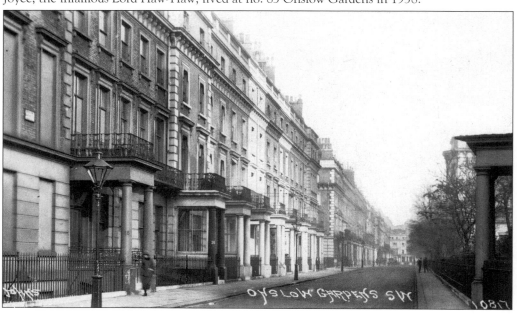

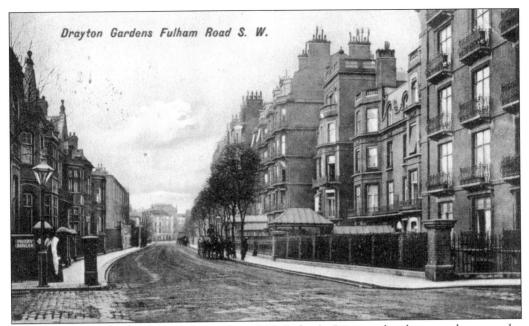

Drayton Gardens, *c.* 1905 (above) and *c.* 1925 (below). Prior to development here, at the beginning of the nineteenth century, this was called Thistle Grove (the present Thistle Grove was called Thistle Grove Lane). The houses depicted in both these scenes were in the main erected in the 1880s.

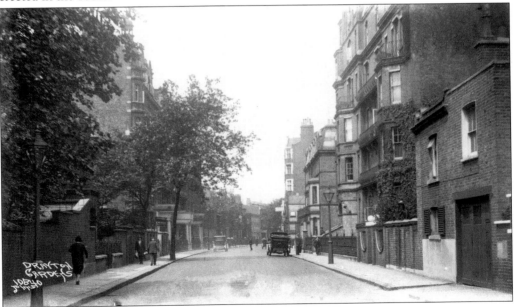

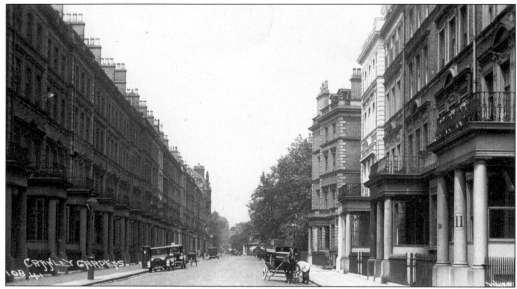

Cranley Gardens, *c.* 1930. The houses to the north of St Peter's church were built between 1877 and 1880, while those to the south, nearer the Fulham Road and shown in the lower view, were built in 1883 in red brick in 'Queen Anne' style by C.H. Thomas. Cranley was the second title of Lord Onslow.

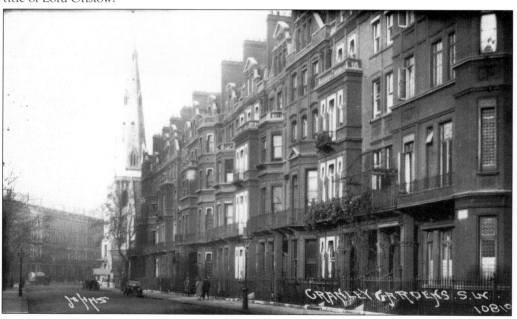

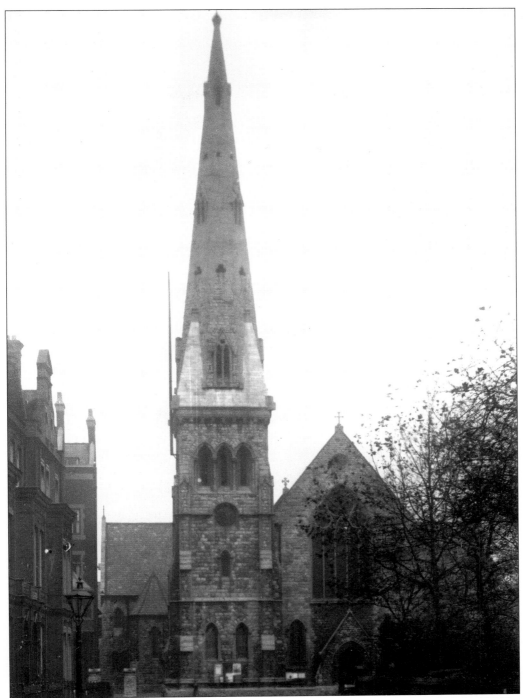

St Paul's church, Cranley Gardens, *c.* 1930. The foundation stone was laid on 21 July 1866 by Mrs Freak, wife of the architect and benefactor of the church, Charles James Freak. The church was consecrated on St Peter's feast day, 29 June 1867. The church was declared redundant in the 1970s and was taken over by the Armenian Orthodox Church.

Tregunter Road, *c.* 1930. The road name stems from a home of the Gunter family, in Brecknockshire. The first properties built here were on the south side of the road in 1852 together with most of those in Gilston Road and the eastern side of The Boltons. Numbers 25 and 27 Tregunter Road were built in 1864.

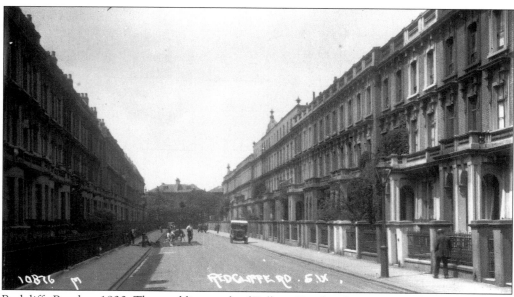

Redcliffe Road, *c.* 1930. The road lies north of Fulham Road and connects with Cathcart Road. The road is presumed to have been named by the architect, G. Godwin, who had restored the church of St Mary Redcliffe at Bristol and had worked on other buildings in the Bristol area. The builders, Corbett and McClymont, had commenced their works here in 1861 and by 1863 Corbett had moved into no. 14 and McClymont had taken up no. 22 for himself.

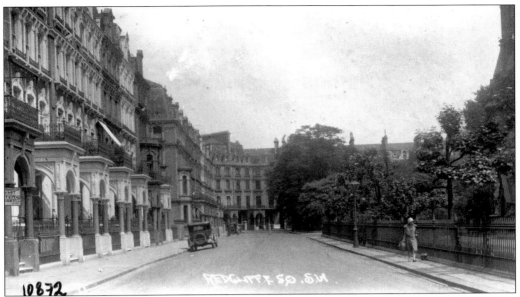

Redcliffe Square, *c.* 1930. Mr Peter Jones, of the Sloane Square department store, lived in the square.

Redcliffe Gardens, both views about 1930. On the 1822 map of Kensington Parish, Redcliffe
Gardens is shown as Walnut Tree Walk.

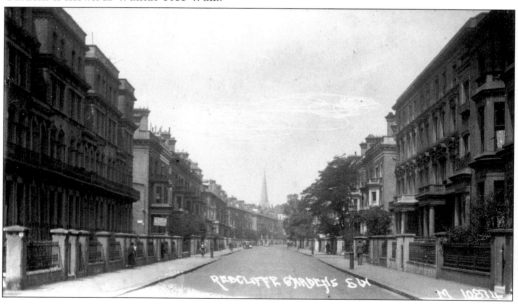

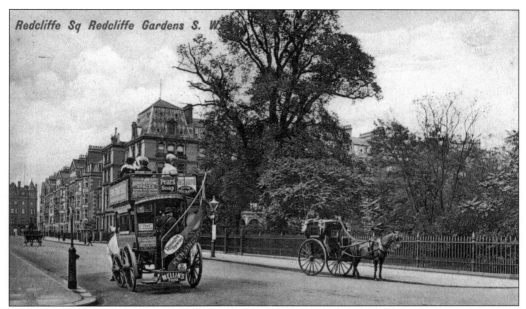

Redcliffe Gardens, *c.* 1905. On the approximate 82 acres of the Redcliffe Estate land, developed up to 1882, there were constructed 1,100 houses, two churches, approximately ninety mews premises and five public houses. Of the houses, 670 were on Gunter property and 220 on lands belonging to R.J. Pettiward. The majority were under building leases to William Corbett and Alexander McClymont.

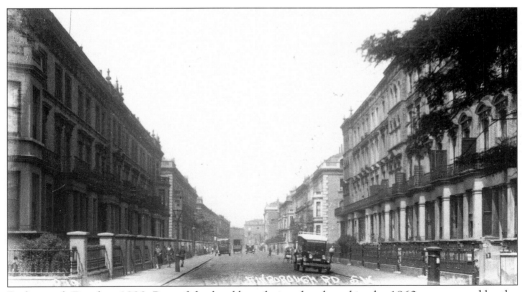

Finborough Road, *c.* 1930. Part of the land here being developed in the 1860s was owned by the Pettiward family, who had an estate at Finborough, Suffolk. A small portion of land was purchased from R.J. Pettiward in 1867 to complete some of the properties in Finborough Road and nearby Ifield Road. The houses near Redcliffe Square – Nos 72-82 – were built between 1872 and 1876.

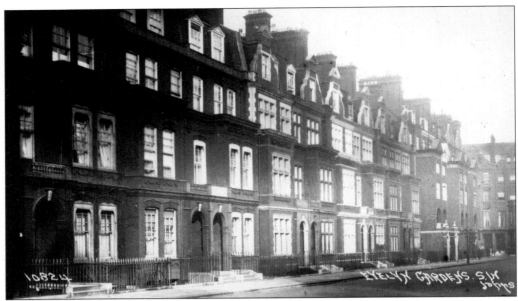

Evelyn Gardens, *c.* 1930. St Peter's church, Cranley Gardens, is in the background in the picture below. The Smith Charity land development here was altogether different to their previous stuccoed designs, and 'Queen Anne' style houses of some character were built between 1886 and 1892. Praise was given for adding the gardens on the south as a 'buffer' to the traffic noise on the Fulham Road. The developer of Evelyn Gardens was Charles Townsend Murdoch but the architect's name is unknown. Evelyn Gardens is named after Sir John Evelyn, a trustee of the Smith Charity.

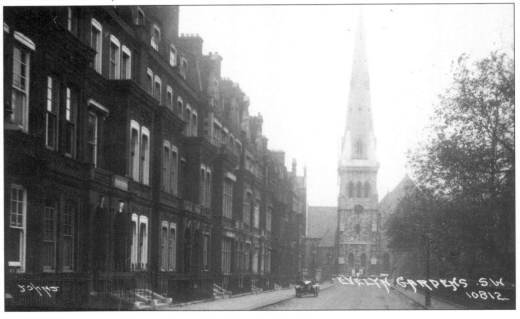

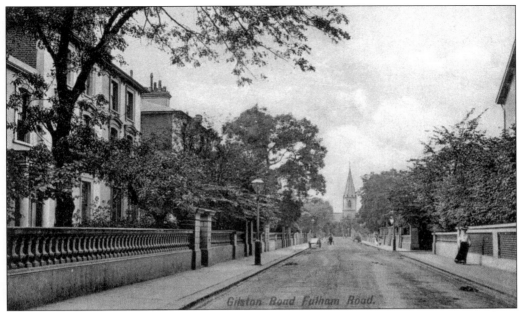

Gilston Road, *c.* 1905. The scene is facing north from Fulham Road, with St Mary's church, in The Boltons, in the background. The church was designed by George Godwin, surveyor to the Gunter Estate. Gilston Road is named after a home of the Gunter family in Brecknockshire. A builder from Chelsea, Robert Trower, built no. 26 here in 1850, while at the same time building a terrace of houses in nearby Priory Walk. The other houses in Gilston Road were built in the following five years.

Harcourt Terrace, *c.* 1930. This road leads north from Tregunter Road. Harcourt Terrace was part of the Gunter lands developed in 1866/67 by Corbett and McClymont, who were declared bankrupt in 1878 with liabilities of £1.25 million, a phenomenal sum even by today's standards.

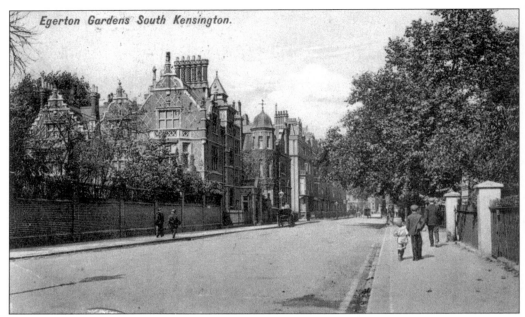

Egerton Gardens, *c.* 1905. The building on the left is Mortimer House, which backs onto Brompton Road. The house was built in 1886 for a Mr E. Howler Palmer by William Goodwin; the architect is unknown. The 'Jacobean' and 'Tudor' style house is of red brick diapered with blue bricks and has Portland stone dressings, decorated chimneys, several designs of gable ends and turrets. The house is still a pleasure to see.

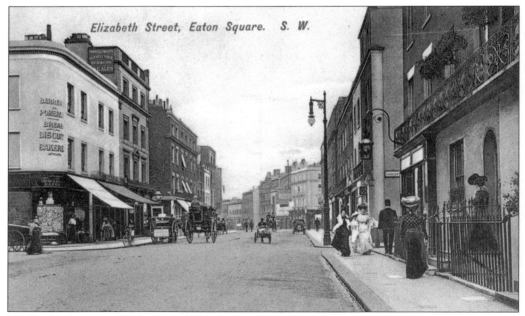

Elizabeth Street, *c.* 1905. Gerald Road is to the right and Chester Square is on the left. The scene has not changed in almost 100 years except that the shop's merchandise is of far better quality and that estate agents have replaced some of the family shops.

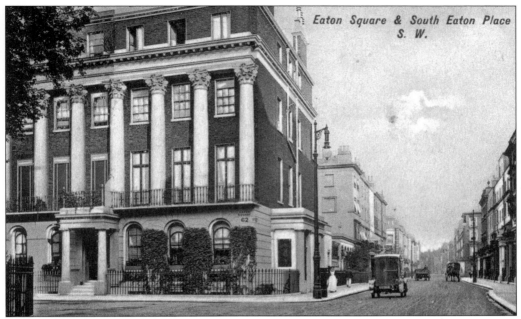

Two views of Eaton Square, both from around 1905. Thomas Cubitt was to develop much of
Eaton Square on Grosvenor Estate lands in the years following 1821 when Buckingham House
became a royal palace. The area, previously marshy and comprising market gardens called the
Five Fields, was levelled with earth removed from the construction of St Katherine's Dock.
Cubitt's buildings of the late 1820s had a restrained, classical quality with long unified terraces
amid semi-formal gardens. The square is named after Eaton Hall in Cheshire, the family seat of
the Dukes of Westminster.

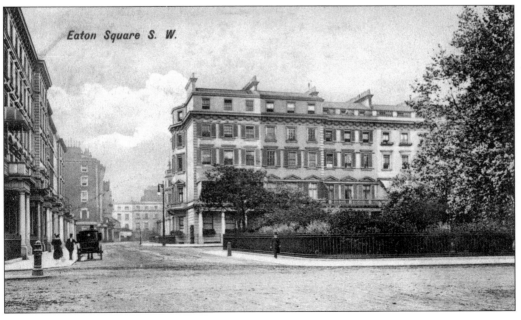

Eaton Square S. W.

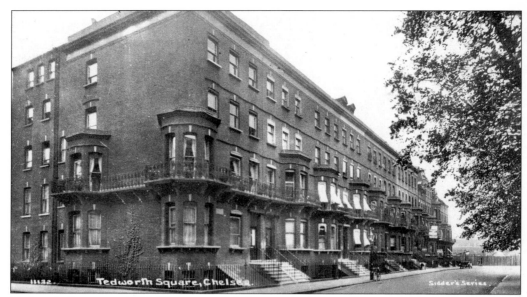

Tedworth Square, *c*. 1910. The actress Lily Langtry had several homes in Chelsea; at one time she lived at no. 15 Tedworth Square. The American author Mark Twain stayed at no. 23 for approximately six months. The two views on this page were deemed important to include but are unfortunately out of sequence.

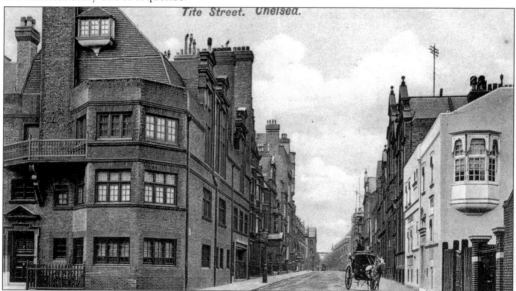

Tite Street, *c*. 1905. At no. 34 is a blue plaque to the memory of Oscar Wilde, who lived here from 1884 to 1895. The portrait painter John Singer Sargent had his studios at nos 33 and 31 (now 13 and 11) from 1885 until his death in 1928. Another portrait painter, Augustus John, moved his studio to no 33 (13) in 1940. The building on the right, called rather obviously The White House, was built for James McNeill Whistler by Charles Godwin in 1886. Unfortunately, in 1961 it was discovered that the foundations were not sufficiently strong and it was demolished. The replacement, a similar-looking house, designed by André Mauny, was completed in 1966.